WALES

A WALK THROUGH TIME

FLAT HOLM TO BRECON

BRIAN E. DAVIES

AMBERLEY

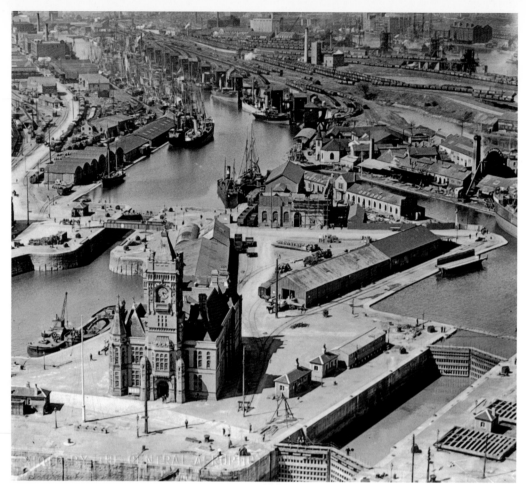

Cardiff Docks and Pier Head, 1923.

To my wife Mari – my own 'Mari Dirion'

First published 2011

Amberley Publishing
The Hill, Stroud
Gloucestershire, GL5 4EP

www.amberleybooks.com

Copyright © Brian E. Davies 2011

The right of Brian E. Davies to be identified as the
Author of this work has been asserted in accordance
with the Copyrights, Designs and Patents Act 1988.

ISBN 978-1-84868-707-3

British Library Cataloguing in Publication Data.
A catalogue record for this book is available from
the British Library.

Typesetting & Origination by Amberley Publishing.
Printed in the UK.

Contents

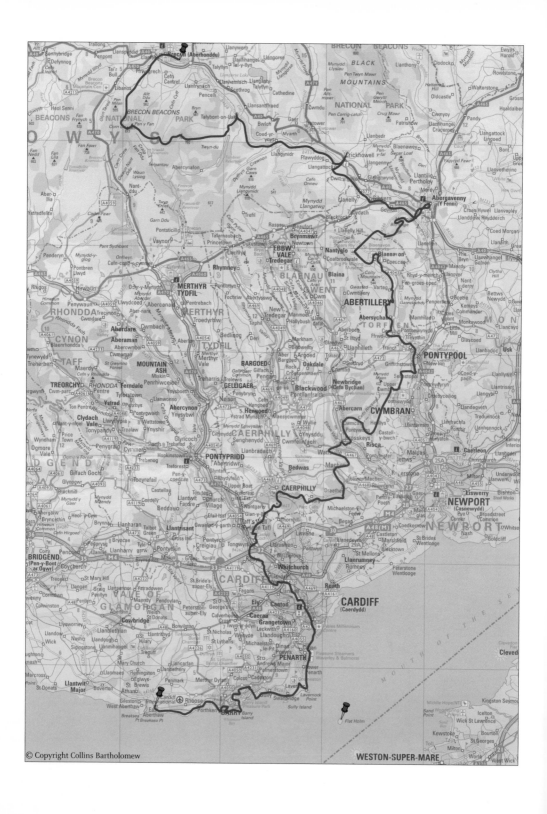

Acknowledgements

I'd like to thank my friends Pat Ward, for his expert help with the colour photographs, and Bill Kenny, who trekked over the Brecon Beacons with me. The following kindly contributed photographs and information: National Museums of Wales, Llyfrgell Genedlaethol Cymru/National Library of Wales, Francis Frith Collection, Flat Holm Project, Cardiff Council, Glamorgan Archives (Ref DX446/2, DX998, D255), Glyn Jones, Barry Amateur Radio Society, Tom Clemett, Vale of Glamorgan Council, Associated British Ports, Penarth Society, Cardiff Harbour Authority, Butetown History & Arts Centre, Cardiff Central Library, Cadw (The Historical Environment Service of the Welsh Assembly Government), Caerphilly County Borough Council, Caerphilly Library, Ruperra Conservation Trust, Dennis Spargo, Machen Remembered, Tony Jukes, Risca Industrial History Museum, Deborah Hayward, Alan Lewis, Gwent CAMRA, Torfaen County Borough Council, Torfaen Museum Trust Pontypool, The Free Press, The South Wales Coalfield Collection Swansea University, Tom Roberts, Blaenavon Industrial Landscape World Heritage Site, Community Heritage & Cordell Museum, Monmouthshire County Council, Abergavenny Museum, Chris Barber, Ronald Watts, Dr Damian P. O'Connor, Haileybury College, Crickhowell District Archive Centre, John Addis, Ian Bell, B. J. Ashworth, Brecon Beacons National Park Authority, Richard Mears, Brecknock Museum & Art Gallery, Malcolm John, Regimental Museum of the Royal Welsh Brecon, Brecon Jazz, and many others who helped.

Publications referred to include: *Flat Holm Island, Maritime Wales, Lloyd's Register, The Essential Cardiff Castle* (Matthew Williams), *Taff Trail Guidebook* (Jeff Vinter), *Wild Wales* (George Borrow), *A Search into the Past* (Millie Cadwell), *The Story of Torfaen, The Brecon & Abergavenny Canal* (John Norris) and Town Trails and Guides for Barry, Penarth, Cardiff Bay, Caerphilly, Pontypool, Blaenavon, Abergavenny and Brecon, in addition to numerous walk leaflets produced locally. The internet has also been invaluable, especially the websites www.cwmbran.info and www.welshcoalmines.co.uk.

Ordnance Survey Maps reproduced: © Crown Copyright. All rights reserved. Licence number 100050463.

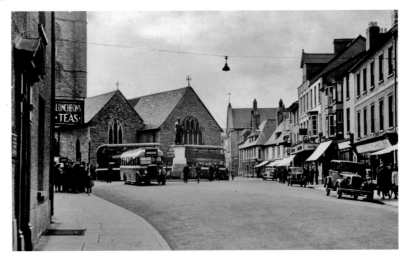

Brecon town centre, 1950s.

Introduction

On 22 January 1879, over 1,300 British soldiers and their allies were massacred by the Zulus at the Battle of Isandlwana, and around 600 men of the 24th Regiment of Foot were among the slaughtered. In the aftermath, some 4,000 Zulus crossed the Buffalo River and attacked the mission station at Rorke's Drift, where a single company of the 24th had been left to guard the post. These men had arrived in southern Africa recently, fresh from their base in Brecon, and were comparatively young and inexperienced. What followed was destined to become legendary in British military history as an epic of courage and endurance. Two years later, the 24th Regiment was renamed the South Wales Borderers, and the Regimental Museum in Brecon now provides a lasting tribute to their proud history.

The historic town of Brecon is a fitting destination for our Walk Through Time, but the starting point of Flat Holm Island, the southernmost outpost of Wales, has its own stories to tell. Some ten years before the heroic events in Africa, the Victorian fortifications on this island in the Bristol Channel were completed. There was grave concern in the 1860s that the French would again become a threat, and a string of heavy defences was constructed around the coast, including those on Flat Holm. In the event, the huge guns were never fired in anger.

Our 115-mile walk is part of a journey from the southernmost to the northernmost point in Wales and will ultimately finish in Anglesey. I've chosen a winding route and accompanying images to reflect the history and character of Wales, and each chapter represents a day's walk. Distances vary, although the longest sections can be divided or shortened – the visit to Flat Holm Island obviously includes a boat trip! The walk passes the most southerly point on the mainland before following the coast to Cardiff Bay. After making its way through the city, the route visits the valleys before arriving at Blaenavon's World Heritage Site then entering the Brecon Beacons National Park. We visit Abergavenny and follow the Monmouthshire & Brecon Canal, with the final chapter featuring a trek over the Brecon Beacons.

The 1/50,000 scale OS maps and descriptions in the text should enable the route to be followed without difficulty. I haven't detailed every single turning and stile, as it's important there's scope for exploration and changes can occur over time. More detailed 'Explorer' OS maps are a useful additional aid, and a compass should always be carried.

In reading George Borrow's account of his walk through 'Wild Wales' in 1854, I noted the many inns and taverns he visited and felt it would be remiss of me not to pay attention to some of the hostelries along the route! These are well placed to provide refreshment for the weary traveller, and they take their place in our journey through time.

Brian E. Davies
1 March 2011

Flat Holm Island

'Are you ready?'

The southernmost tip of Wales is Lighthouse Point on the small island of Flat Holm (Ynys Echni) in the Bristol Channel, some 5 miles south of Cardiff Bay. The Flat Holm Project boat *Lewis Alexander* operates a scheduled passenger service to the island, and an exploration of Flat Holm is an attractive prelude to the main walk. Boat departures are currently from the Barrage South Water water-bus stop at Penarth Marina and sail from March to October. The trip takes about 50 minutes, including locking through Cardiff Bay Barrage – itself an interesting experience.

The island has a long and fascinating history dating back to the late Bronze Age, and early Celtic saints appreciated the tranquillity of the island. Vikings later used it as a base when raiding in the Channel, and it has been used for lead and silver mining. Its isolated location made it a smugglers' paradise, with numerous caves and old workings that were useful for storing contraband. The island's isolation also led to the establishment of a cholera hospital there.

Flat Holm was heavily fortified in Victorian times and again during the Second World War, and much evidence of this remains, including the barracks and gun emplacements. The prominent lighthouse has long been an important landmark for mariners in the Channel.

The island (*below*) is roughly circular, about 500 metres across and, as its name suggests, is flatter than its English neighbour, Steep Holm island.

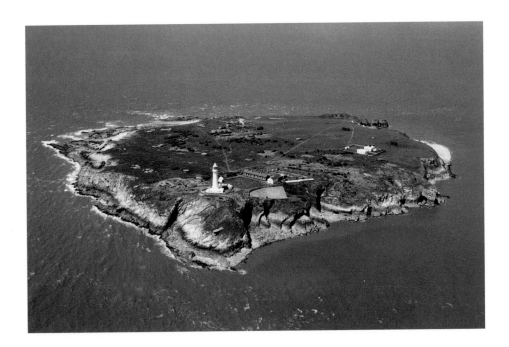

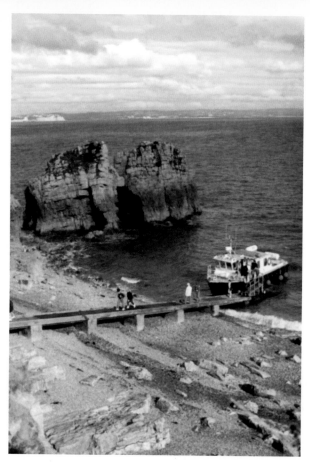

The boat arrives at the East Beach jetty (actually to the north) under the imposing Castle Rock (*left*) and a track leads southwards past the foghorn station towards the barracks and lighthouse. The island is a haven for wildlife and is designated a Local Nature Reserve. The northern half is managed grassland, grazed by sheep and rabbits, with many disused rabbit burrows being used by nesting shelduck. The gull colony is concentrated to the south, where Lesser Black-backed and Herring gulls breed. To the right of the track is the farmhouse with the old cholera isolation hospital nearby. The foghorn station was built in 1908 and, although now silenced, has been carefully restored by volunteers from the Flat Holm Society, a charity dedicated to promoting the island. The Victorian barracks is now used as an educational centre and museum and has a small shop. The map (*below*) is 6 inches to one mile in scale, published in 1961.

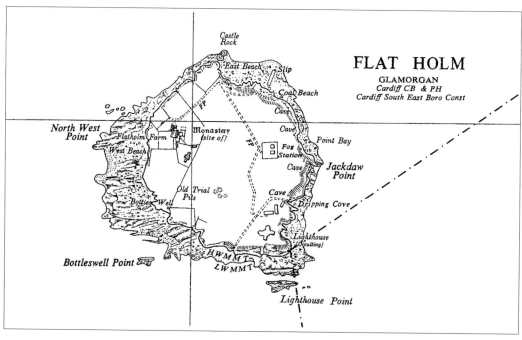

FLAT HOLM

GLAMORGAN
Cardiff CB & PH
Cardiff South East Boro Const

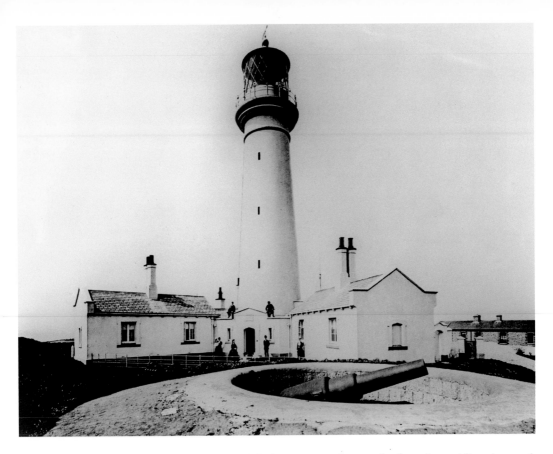

The lighthouse was established in 1737 following a tragic shipwreck when sixty soldiers drowned. Its coal-fired brazier consumed over half a ton each night, which had to be carried manually to the top of the tower. The brightness of the light was often disputed and, after the loss of the *William and Mary* with fifty lives off the nearby Wolves rocks in 1817, Trinity House took over the lease in 1819 and installed an oil-burning lantern. The light has been substantially upgraded over time and is now solar-powered and fully automated, having been unmanned since 1988.

The substantial Victorian fortifications were constructed in the 1860s when Palmerston was vexed about the military threat from France. A ring of coastal forts was ordered, and four artillery batteries were established on the island to help protect the Bristol Channel. Because of the relatively flat and exposed terrain, the heavy guns were mounted on 'Moncrieff Disappearing Carriages' concealed in pits, raised only for firing. The gunner who was persuaded to raise the gun for the *c.* 1875 photograph (*above*) was severely reprimanded because the gun was on the secret list! The photographer was chased for the negative but managed to save it by promising not to publish without permission. The guns were never needed and the forts became known as 'Palmerston's Follies'. The pits and magazines are interesting to explore, and a number of the huge gun barrels are still lying around – too heavy to move.

The barracks and other buildings were reused during the Second World War, when over 350 soldiers were based on the island, with further gun emplacements supported by command posts, searchlights and radar. After Flat Holm became non-operational in December 1944, German prisoners of war removed most the military equipment.

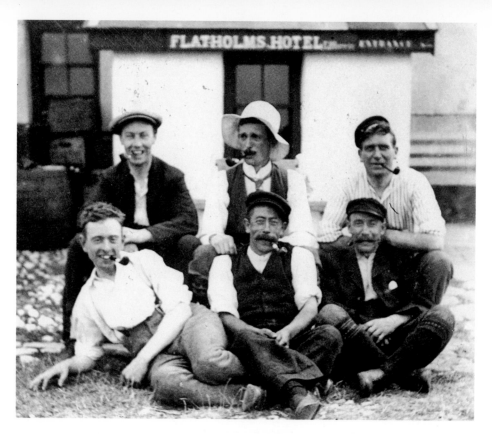

Farming on Flat Holm dates from medieval times, and the rebuilt farmhouse was originally sixteenth-century. The Harris family moved here from Steep Holm in 1885 and established the 'Flatholms Hotel' (*above*). There was a bar in the farmhouse and a skittle alley alongside and trade was good, with day trippers and Channel pilots enjoying 'sunset to sunrise' hospitality, including Sundays (when Wales was 'dry').

In 1922, the hotel was prosecuted for selling intoxicating liquor outside permitted hours. Frank Harris's claim that the pub was outside the 3-mile coastal limit of jurisdiction was disproved by the prosecution, who measured a straight line from Lavernock Point at the lowest tide of the year! Thereafter, the hotel had to comply with mainland opening times. Trade suffered and the licence was surrendered in 1935.

The farm may have been associated with running of contraband in times past, but nothing was ever proved. The island was certainly a favourite haunt of smugglers, and in 1734 Customs officers were ordered to visit Flat Holm to put a stop to it. Smuggling was also clearly taking place in Victorian times, when a cave in the east cliff was described as 'well-filled with kegs of brandy that have never paid the Queen's dues'. The farmhouse was taken over by the Army in 1941 and served as the officers' mess. It now accommodates visitors.

The old cholera hospital, built in 1896 to isolate suspected cases, replaced an earlier tented hospital. It dealt with other diseases, such as yellow fever and plague, but by the 1930s was no longer needed. It became the NAAFI during the Second World War.

Perhaps Flat Holm is most famous for the first radio transmission made across water. Guglielmo Marconi (*right*) came to Wales because he was unable to gain support for his work at home in Italy. William Preece, a Welshman and a senior figure in the field, was experimenting in the area and encouraged Marconi to come to Flat Holm. Two 110-foot masts were erected on Flat Holm and at Lavernock Point on the Welsh mainland and, on 13 May 1897, 23-year-old Marconi, with his assistant George Kemp, sent the first ever wireless messages over the sea – the Morse slip 'Are you ready?' is preserved for posterity in the National Museum of Wales. The first steps in wireless telegraphy had been taken, starting a revolution in communication for the twentieth century which changed lives profoundly. The print (*below*), which captures much of the magic of Flat Holm island, shows Marconi's mast.

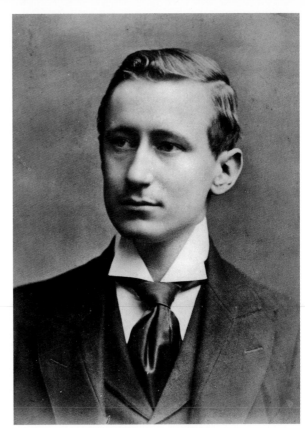

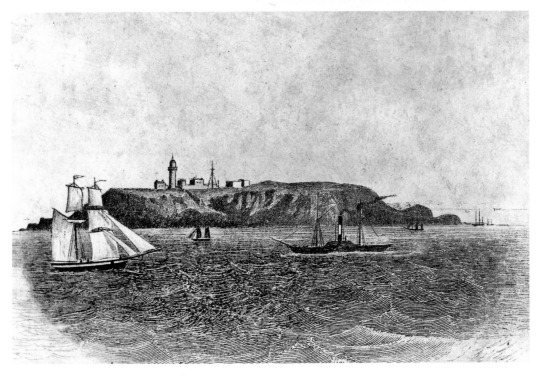

Chapter Two

East Aberthaw to Barry

10.4 miles (16.7 km)

'Y Pwynt Mwyaf Deheuol – The Southernmost Point'

The walk begins at a historic pub and follows the coast to the southernmost point on the Welsh mainland before passing through Porthkerry Country Park on the way to the popular seaside resort of Barry Island and the town of Barry with its redeveloped waterfront and docks.

The beautiful thatched Blue Anchor Inn at East Aberthaw (*below*) is said to date from 1380 and has thrived since the days when Aberthaw was a busy port on the estuary, trading near and far. The inn has prospered through the centuries, apart from a forced closure in 2004 when a serious fire destroyed the upper storey. The building has been expertly restored and its old stone walls could tell many a story, such as the account in 1735 of a drunken rum smuggler who came ashore with a cask on his back and was chased by customs officers. The pub was featured in the ITV series *Great Pubs of Wales*.

Our walk route goes down the lane opposite the inn and under the railway bridges, going left to follow the coast around to the east. The giant coal-fired power station dominates the area now and it's difficult to visualise the old medieval port.

The path passes the interesting ruins of the old Aberthaw Lime Works, which produced lime from limestone pebbles until its closure in 1926, then continues along the top edge of the beach.

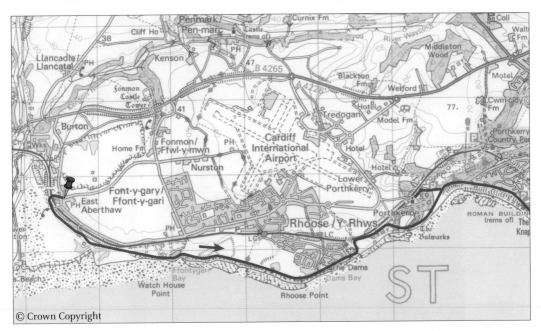

Steps lead up to Fontygary Leisure Park, and the path follows the edge of the caravan site with great views of the Bristol Channel. After passing Rhoose Lifeguard Club, the path continues along the coast, eventually reaching Rhoose Point with its stone circle and monument marked with a Celtic cross and 'Y Pwynt Mwyaf Deheuol – The Southernmost Point'. The 10.5-ton pillar of slate (*right*) was transported here from Bethesda Quarry in North Wales and erected in the year 2000 to mark the southernmost point and commemorate the completion of a ten-year land reclamation scheme by Blue Circle Industries. The area was once the site of quarries and a cement works but now includes a nature reserve and new housing. A number of other interesting land art stone sculptures made using Rhoose limestone are featured hereabouts.

The Bristol Channel has a reputation as a dangerous place for shipping; the Great Gale of 1908 wreaked particular havoc.

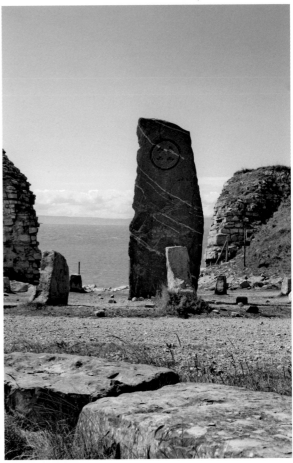

13

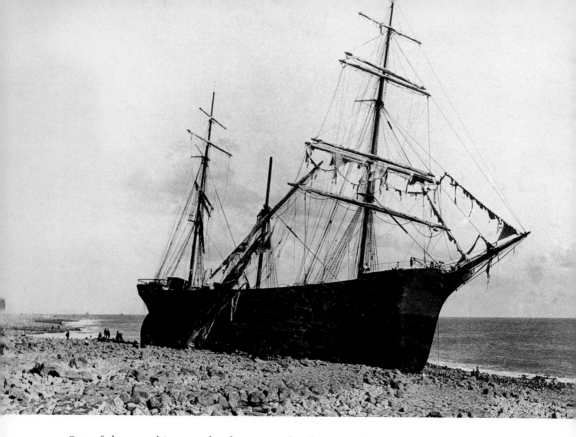

One of the casualties was the three-masted sailing vessel *Verajean*, wrecked off Rhoose Point (*above*). She left Cardiff bound for Chile with a cargo of 3,171 tons of coal bricks and headed down channel in strong winds under the tow of two tugs. Near Lundy Island on Monday 31 August 1908, the tows were slipped; but due to the 'hurricane force' storm, her skipper, Captain Ritchie, decided to head back to Barry Roads for shelter. Unfortunately, she lost both her anchors, and her headsails were blown away. She was driven aground on Rhoose Point in the early hours of Tuesday 1 September. Her crew were able to get ashore, but she was badly holed and lost her main topmast. The ship was stranded for ten days; to lighten it, the cargo was unloaded onto the beach. Apparently, grateful locals filled their coal cellars with enough fuel for two winters! Unfortunately, the vessel was too badly damaged for repair and was later towed to Briton Ferry for breaking up. She was luckier than the barque *Amazon*, which ran aground on Margam Sands in the same storm with the loss of twenty-one of her crew of twenty-eight. The gale also caused extensive damage inland.

The path continues along the coast, diverting around a disused quarry and through a caravan site before passing The Bulwarks, an Iron Age fort, and dropping down to the shore at Porthkerry Country Park.

The little village of Porthkerry is well worth a short detour, and a path leads up through the woods to the delightful St Curig's church near the village green. A simple gravestone in the churchyard records 'A Seafaring Man Found Drowned 1866'. Returning downwards, the Porthkerry viaduct makes for an impressive sight with its high semicircular arches (*above right*).

14

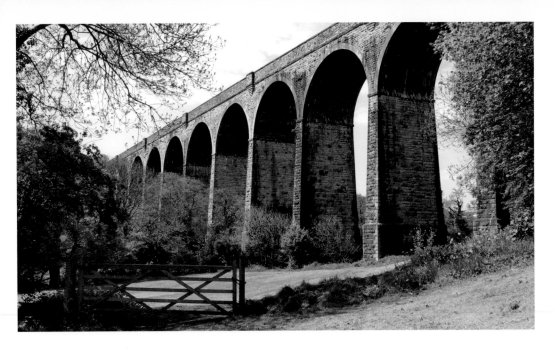

The railway viaduct opened in 1900, linking collieries in the valleys to Barry Docks; but now it carries coal the other way, to Aberthaw power station, as well as passengers on the Vale of Glamorgan line.

The route leaves the Country Park by the 'Golden Stairs' that ascend steeply through trees to Bull Cliff. Then we pass along a grassy path to drop down into The Knap, with its attractive park and harp-shaped lake. The promenade leads to Watch House Bay past a grassed-over area, once the site of Cold Knap Lido. The lido, pictured (*below*) in the 1970s, was once one of the largest and most well-known outdoor pools in the country.

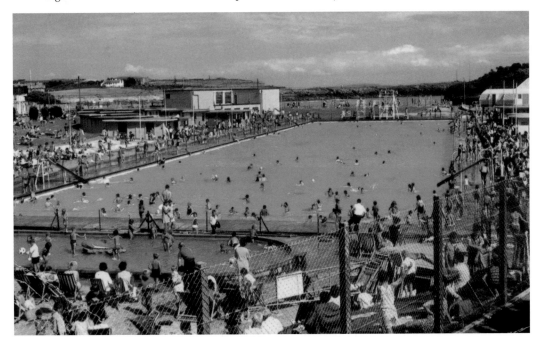

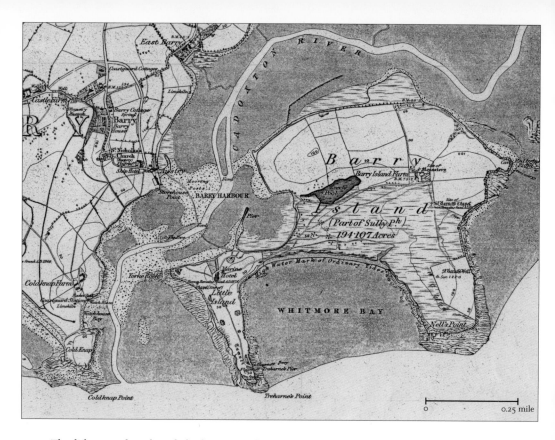

The lido complex, demolished in 2004, has now disappeared but is fondly remembered. From Watch House Bay the route continues around to the Ship Hotel and crosses the causeway to Barry Island. The map (*above*) shows Barry Island in 1886, when Barry itself was just a hamlet west of the island and the Ship Hotel overlooked the ford that crossed the Cadoxton River. Before the causeway was built in 1896, access to the island was restricted to short periods around low tide. The island had long been a favoured centre for smugglers and pirates, who could control shipping in the Channel and make use of Flat Holm, Steep Holm and Sully Island to conceal and store their contraband 'until opportunity offered to carry them to other places'. Clearly it was a difficult place to police.

Our route leaves the causeway to follow the old harbour around to the breakwater before crossing Friars Point. The house here was once the site of the first Marine Hotel, built in the 1850s by Francis Crawshay of Merthyr. A ferryboat service across from the Ship Hotel was provided for 'select Victorian visitors'. Later, Mr Treharne bought the island and built a pier near Friars Point to attract passenger boats. Some 15,000 visitors were attracted to the island in 1876, arriving by boat or walking across at low tide.

As we carry on around to the curve of Whitmore Bay, it's easy to see why Barry became a major tourist destination. Thousands of day trippers arrived by train and charabanc, and the annual Sunday School outing to Barry Island was a major treat eagerly looked forward to. The fairground was established by the 1920s and, with its amusement arcades, Punch & Judy shows, and donkey rides on the sands, the resort was booming. The picture (*below*) illustrates the vast crowds of its heyday. The promenade was known as the 'halfpenny prom' in the days when there was payment for access at turnstiles, and the walk along the prom is still as enjoyable as ever. Reaching Nell's Point, our path goes left up the bank to pass to the right of stylish modern housing. This housing replaced Butlin's holiday camp, which occupied Nell's Point for thirty years, catering for 5,000 visitors. The camp closed in 1996.

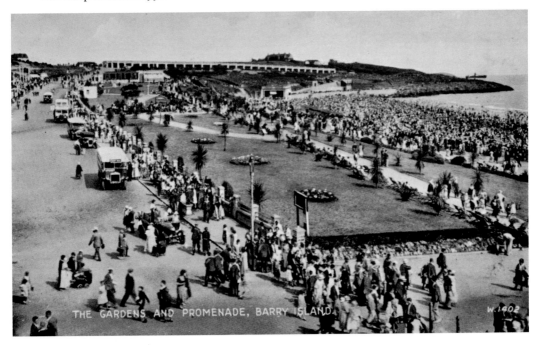

THE GARDENS AND PROMENADE, BARRY ISLAND. W.1402

Down to the right is Jackson's Bay and the harbour and entrance to Barry Docks. The pier down here was once served by its own railway station with the line from Barry Island station arriving through a tunnel. Barry Pier station opened in 1905 and was the most southerly in Wales. It brought large numbers of passengers by rail to the paddle steamers operating from the pier pontoon. The picture (*below*) shows passengers embarking for their Channel cruises, with the lifeboat station and its slipway behind and the breakwater to the left.

Our path passes to the right of a grove of trees guarding the remains of St Baruch's chapel, built in Norman times on the grave of the legendary Celtic saint, who drowned while returning from Flat Holm island around AD 700. His body was recovered from the beach of Barry Island – the resort's name is said to derive from 'Baruch's Island'. Going ahead, the route passes the 'second' Marine Hotel, which dates from the 1890s – its licence was transferred from the old Marine Hotel on Friars Point which was demolished in 1894. Up until 1950, the Marine Hotel was the only licensed premises on Barry Island, but after that date many clubs opened up, offering visitors a choice.

Our route now turns right then left along Clive Place, reaching Clive Road with its great view of Barry Docks and the modern waterfront development, the town stretching up behind.

Going left along Clive Road, past an attractive school garden, a path marked 'Access to Waterfront' leads off to the right – a handy shortcut. The waste ground to the left and the dock's former marshalling yards were once the site of Woodham's Yard, the so-called 'Graveyard of Steam'.

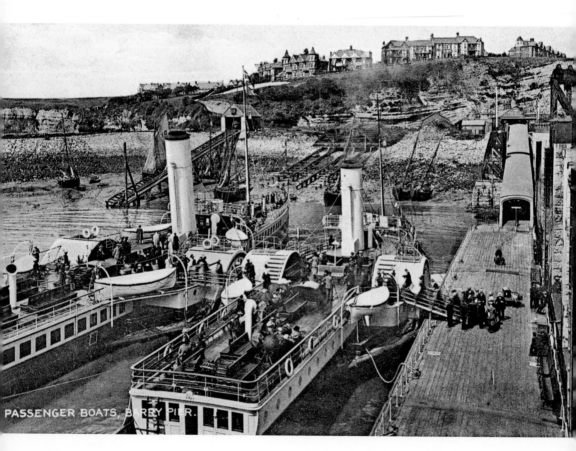

PASSENGER BOATS, BARRY PIER.

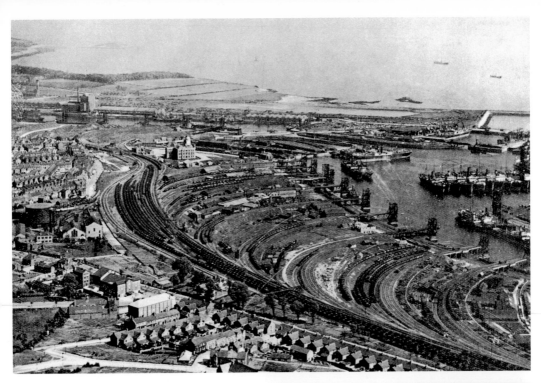

During the 1960s, Woodham's was the UK's largest storage site for steam locomotives awaiting scrapping. With the advent of diesel and electric on British Rail, nearly 300 withdrawn engines were sent here. Eventually over 200 of these historic locos were saved for rail preservation societies, and to many the yard was regarded more properly as the 'Saviour of Steam'.

Turning right towards the impressive waterfront development, we head for the dome of the former Docks Office, seen (*above*) in its dockside setting in the 1920s. The Docks Office, now a Council administrative centre, was built in 1899, with a calendar theme – 365 windows, 12 panels in the porch, 31 steps to the main staircase, 52 marble fireplaces, 7 lights in the window above the original doors, 4 floors and 2 circular windows in the entrance hall (sun and moon). Proudly standing in front is the bronze statue of David Davies (*right*), the main driving force behind the creation of Barry Docks.

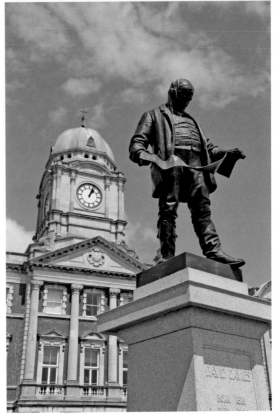

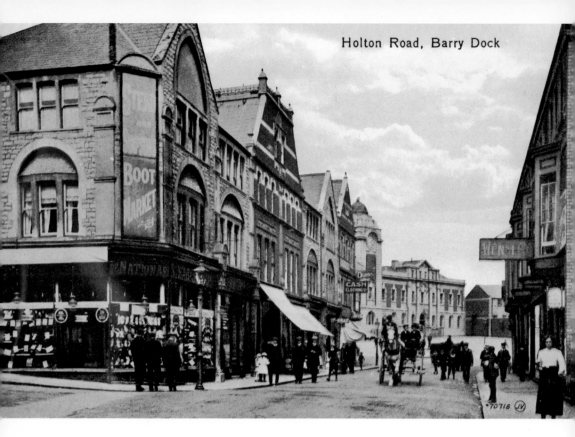

David Davies (1818–1890) was a deeply religious man, strictly teetotal and a generous benefactor – he contributed financial support for the first University of Wales at Aberystwyth.

Barry Docks was developed as a coal port in the late nineteenth century when the Barry Railway Company was formed by a group of colliery owners, with David Davies prominent among them. They were frustrated by the monopoly of the Bute family and their control of the Taff Vale Railway and Cardiff Docks. To avoid these restrictions, a rail route was developed, terminating at Barry, and the dock basin opened in 1889. This was closely followed by the two other docks and it soon overtook Cardiff. In 1913 it exported over 11 million tons, becoming the largest coal-exporting port in the world. Barry became a town almost overnight, its population increasing from a few hundred to 40,000 by the 1920s.

The route passes to the left of the Docks Office, under the railway tunnel, turning left on Dock View Road then right up Thompson Street to turn right on Holton Road, the popular main shopping street. The photograph (*above*) shows Holton Road leading up to King Square and the town hall, which was opened in 1908, a few years before the picture was taken. The municipal buildings have now been impressively refurbished with a modern new library and civic square in front.

Barry to Cardiff Bay

11.3 miles (18.2 km)

'To strive, to seek, to find, and not to yield'

Today's route leaves Barry town centre to cross the eastern end of the docks before rejoining the coast, leaving the industrial scene behind. The coast path passes Sully Island before reaching Lavernock, where Marconi's historic transmission was received on the mainland. The route then turns north to Penarth before crossing the Barrage to the vibrant Cardiff Bay area.

From King Square, the route carries on to the end of Holton Road and passes under the railway bridge, then right on Ffordd y Mileniwm before turning left to go across the docks on Wimborne Road. This private docks road is used by vehicles and walkers during daylight hours, but it should be stressed that this access is not a public right of way and may be closed at any time for security or safety purposes. There's no pavement here so care is needed. The huge chemical complex on the left dominates this part of Barry, but the scenery soon improves when the coast is reached.

Barry Docks, with its repair yards, cold stores and flour mills, was once one of the best ports in the world and the docks were crowded with ships from all over the globe. In more recent times, Barry became well known for bananas – the Geest Shipping Line imported bananas here from the Windward Islands and Barbados from the 1950s until the 1990s, carrying general cargo outwards to the West Indies.

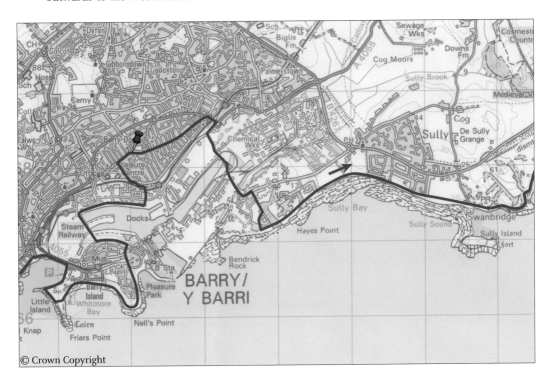

© Crown Copyright

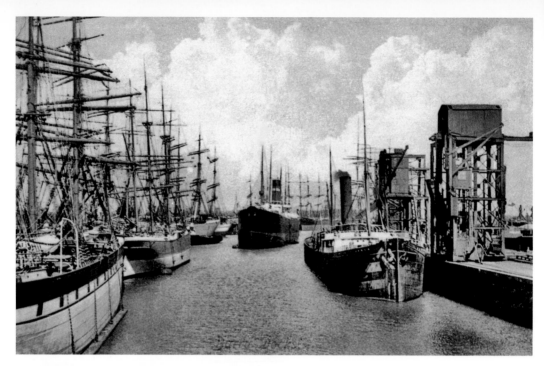

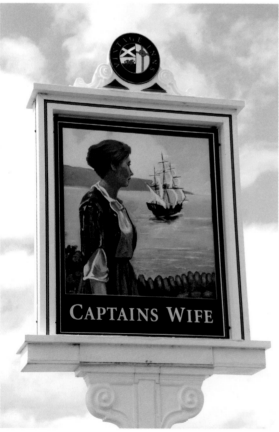

CAPTAINS WIFE

The picture (*above*) from 1908 shows the docks in its heyday with its many sailing vessels as well as steam ships. Barry is still an important trading port handling bulk liquids for the local chemical industries, as well as steel, timber and containers.

After leaving the docks, the route follows Hayes Road left for a short distance before turning right on Hayes Lane. The path passes through a gate to the right of HMS *Cambria* Training Centre and emerges through another gate onto the coast. (If the gates are closed, it's possible to access the beach through the trading estate).

The route turns left here, but to the right, towards Bendrick Rock, there are dinosaur footprints to be found preserved in the stone layers on the beach.

Heading east, the path passes the old Sully Hospital, now smart apartments, before carrying on along the coast to reach Swanbridge and the Captain's Wife pub, overlooking Sully Island. Its colourful sign (*left*) has a story to tell.

Legend says that a ship's captain once lived in a house on the site of the inn. One day he decided to take his wife on a voyage with him even though it was considered unlucky to take a woman to sea. His wife died of a fever during the voyage, and the captain hid the body in a box in his cabin because having a corpse aboard was even more unlucky. He told the crew that she was fine, then, on his return, secretly rowed her ashore. When the time came to transfer her to a proper coffin, he found her body had disappeared from the box! It's said that she still haunts the pub dressed in black because she was denied a Christian burial. There was once a busy harbour and port here and Sully Island was well known for its involvement in piracy and the local smuggling activities.

The coast path at St Mary's Well Bay is unfortunately closed due to a cliff fall, so it's necessary to follow the lane past the caravan park up to the main road, turning right then immediately right again along Fort Road.

The lane into Lavernock passes the Holiday Park with its 'Marconi Inn' sign giving the clue that this is the other end of his radio transmission from Flat Holm. A plaque on the wall of the little church commemorates the fiftieth anniversary of the event, and, on the centenary in 1997, Barry Amateur Radio Society staged a re-enactment (*below*) with equipment similar to that used by Marconi and Kemp.

Lavernock church is one of the few churches left with its stone seats erected against the inside walls – the rich paid for their seats and the poor ended up with their 'backs to the wall'.

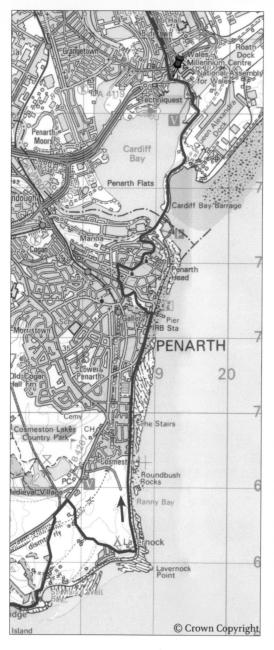
© Crown Copyright

Marconi also transmitted from Lavernock to Brean Down on the Somerset coast, and in recent years there have been well-publicised proposals to construct a more concrete link in the form of a 'Severn Barrage'. This huge project would harness the tidal power of the Bristol Channel, which has the second highest tidal range in the world (after Eastern Canada). It's estimated that the scheme could generate around 5 per cent of the UK's electricity needs and there have been numerous feasibility studies. Concerns about sustainability and the environment, together with the huge costs, have led to the decision not to proceed for the foreseeable future.

The clifftop path from Lavernock to Penarth is a delightful walk and memories of the docks and industrial area fade quickly. It's a good place to watch shipping in the Channel, and soon Penarth Pier appears ahead with the tower of St Augustine's church on the horizon and the Severn Bridge in the far distance. A viewpoint marker points to Flat Holm, Steep Holm, Brean Down and Weston-super-Mare.

The path leads to Penarth's attractive promenade with its hanging baskets, old-fashioned lamp-posts and famous pier built in 1894. The two views (*opposite*) show Penarth from the sands before the pier was built and then the pier with one of the popular paddle steamers alongside. A number of ships have collided with the pier, including one during a dance in the pier's Marina Ballroom in around 1956 – needless to say, the band played on!

The Esplanade Hotel shown in the top picture was built in 1887 but was sadly demolished following a fire in 1977 and has now been replaced by modern apartments. The grand old hotel was the spiritual home of the Barbarians rugby team, who always stayed there on their Easter tour to Wales. The fine former Penarth Baths building next door has happily been preserved, an example of the magnificent Victorian architecture in Penarth. Many grand houses were built here by successful coal and ship owners when Penarth was the third largest coal-exporting port in the world. The town is a pleasure to explore, and a suggested route from the pier leads up through Alexandra Park to Rectory Road, left to the town's elegant library, then right with the art deco Washington Gallery opposite.

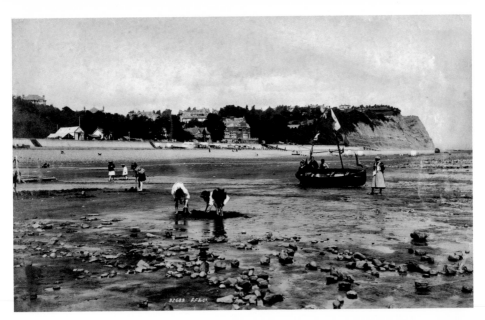

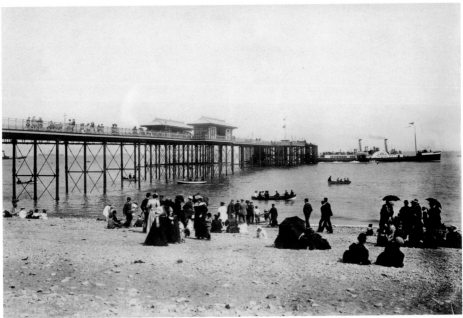

From near the town clock, Glebe Street leads into the characterful Dock Town area, built with the docks in the 1860s. At one time this cosmopolitan area thronged with seamen from many countries and was the town's heartbeat with its shops, many pubs and other drinking clubs as well as religious establishments. A right turn along Salop Street passes the Methodist church on the way to the iconic St Augustine's church, prominent on the headland with its saddleback tower. The grave of Dr Joseph Parry, famous composer of the much-loved song 'Myfanwy', can be found here with its lyre-shaped headstone. St Augustine's Road leads past Headland School, formerly the Penarth Hotel, where Marconi once visited. There are spectacular views of Cardiff Bay as one descends to the old Custom House and the Barrage.

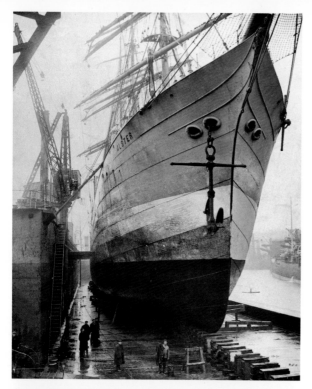

Penarth Dock opened in 1865, its proximity to Cardiff making it ideal for handling massive increases in coal exports. The four-masted sailing vessel *Alster* (*left*) is undergoing inspection on the floating pontoon at Penarth Dock in around 1900, showing the scale of operations here. The *Alster* was built at Harland & Wolff in Belfast in 1890 as the *California*. She was eventually wrecked in 1927 on Old Providence Island in the Caribbean, once a base for the infamous Welsh buccaneer Henry Morgan.

Brunel's famous *Great Britain* sailed from here in 1886 on what proved to be her last voyage, and by the early 1900s Penarth Dock was handling mainly steamships. The dock finally closed in 1963 after almost a century of operations, becoming today's attractive marina development.

There was once a tunnel under the River Ely, linking Penarth with Cardiff. Built in 1902 and half a mile long, it was originally lit by gaslight and survived until 1963. The link is now provided by the impressive Barrage, a perfect walking route across to Cardiff Bay. The 1.1-km Barrage was completed in 2000 and created a huge lake that covered the ex-tidal mudflats of the Ely and Taff estuaries. Despite concerns prior to its construction, it's now regarded as a major asset, vital to the ongoing regeneration of the waterfront. The Barrage provides a 'landscaped linear park', great for watching activities in the bay and very popular with walkers and cyclists. The aerial view of the Penarth end (*left*) shows the outer refuge harbour and three locks, with the marina development and River Ely behind.

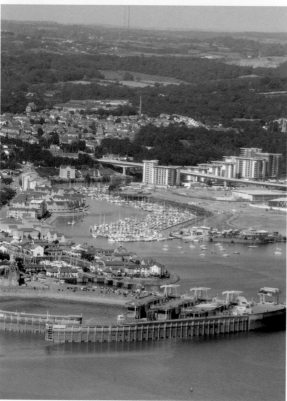

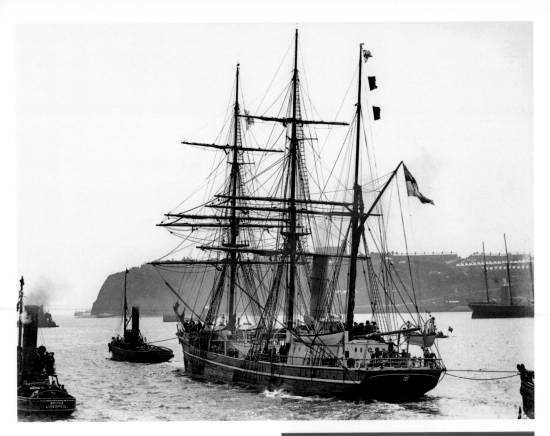

Captain Scott's ship *Terra Nova* sailed from Cardiff on 15 June 1910 (*above*), beginning Scott's heroic but ill-fated expedition to the South Pole. The ship left Cardiff to the cheers of vast crowds, the British Antarctic Expedition having been generously supported by the city. Scott and his party eventually reached the Pole on 17 January 1912, only to find the Norwegian flag flying – Amundsen had beaten him to it by just a month. Retracing their steps in appalling weather, Scott and his four companions sadly perished but created one of the great legends of human endeavour.

The Norwegian Church Arts Centre in Cardiff Bay (*right*), with the statue of Captain Scott and flag flying, is a poignant, if ironic, reminder of these noble events. The church is a replica of the original seamen's church that once stood on the side of West Bute Dock and was where the children's writer Roald Dahl was christened.

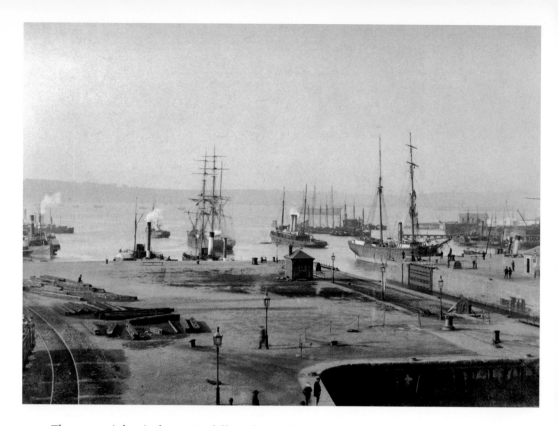

The scene (*above*) shows Cardiff Docks in the 1870s, when the docks were rapidly expanding to meet worldwide demand for Welsh coal. The growth of Cardiff into a major maritime centre began with the Industrial Revolution and the mining of coal and iron in the South Wales valleys. To bring these valuable commodities to port, the Glamorganshire Canal was opened in 1794, followed by the Taff Vale Railway in 1840. The Marquess of Bute developed the Bute West Dock with its Oval Basin in 1839 and, as the volume of coal and shipping increased, the Bute East Dock, Roath Dock and Queen Alexandra Dock followed. The surrounding area of Butetown became a melting pot of nationalities as seafarers and traders came from all over the world and Tiger Bay was born. Cardiff was transformed into the largest coal port in the world, and the town grew enormously. Coal exports peaked in 1913 when over 10 million tons were exported and the international price of coal was fixed at Cardiff's Coal Exchange. The world's first £1 million deal was done here.

Inevitably, markets eventually declined and following the Second World War the docks were run down. The area became a neglected wasteland, a scene emphasised by the unsightly mudflats of the bay. The area was to be transformed, however – the Cardiff Bay Development Corporation was formed in 1987 and set about the challenging task of regenerating the bay and reuniting the city with its waterfront. In 2000, five successor bodies, including the local authority, took over the role of the Corporation. Through a series of public and private sector partnerships, significant large-scale investment has been attracted and the redevelopment continues at pace.

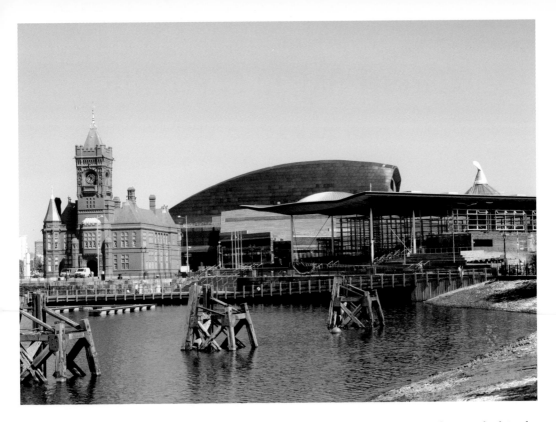

The effort to put Cardiff back on the map as a superlative maritime city has resulted in the splendid scene we see today.

Our walk route passes three iconic buildings on the waterfront (*above*), the three wooden piers serving as reminders of the past. The brick and terracotta Pierhead Building was constructed in 1897 as the headquarters of the Cardiff Railway Company, previously the Bute Docks Company. A large panel on the west side symbolises this, including a locomotive and merchant ship and the motto '*Wrth Ddwr A Than*' (By Fire and Water) proclaiming the triumph of steam power. The futuristic Senedd building was officially opened on St David's Day 2006 and holds the debating chamber of the Welsh Assembly Government. Devolution came to Wales in 1999, and the building's environmental design reflects openness and democracy and uses traditional materials, including Welsh slate and oak. The Wales Millennium Centre with its curved copper roof provides a perfect backdrop to the scene. Opened by HM The Queen in 2004, it's the home theatre of the internationally acclaimed Welsh National Opera and houses the Tourist Information Centre. It faces the Oval Basin, now renamed Roald Dahl Plass in honour of the 'Big Friendly Giant'.

Further on, at Mermaid Quay, many restaurants with their international cuisines reflect the cosmopolitan background of the area. The Terra Nova pub here is another reminder of Scott's expedition and his association with the city. One of Scott's companions on the journey to the South Pole was Welshman Petty Officer Edgar Evans from Gower, whose memorial at Rhossili church bears Tennyson's lines, 'To strive, to seek, to find, and not to yield.'

Cardiff Bay to Caerphilly

13.1 miles (21.1 km)

From Tiger Bay to the Green Lady

Leaving Mermaid Quay, we set off up the mile-long Bute Street, once the main artery linking the docks with the city. Today's walk takes us through Cardiff city centre and follows part of the Taff Trail before heading over the mountain into Caerphilly.

Lower Bute Street has changed dramatically, but the Packet Hotel reminds us of earlier days. The photograph (*below*) looks north along Bute Street in the 1930s, and The Packet is one of the few remaining early dockland pubs, dating from 1864. There were around thirty pubs in Bute Street a century ago – unsurprisingly, the area had the highest incidences of drunkenness in Cardiff. On the right of the street is Butetown History & Arts Centre which preserves and displays the history and culture of Cardiff Docklands with its unique blend of ethnic, racial and class backgrounds.

It's said the district derived the name Tiger Bay from the tigerish tidal currents in the bay, and, like many dockland areas, it acquired a reputation as a rough and dangerous, vice-ridden locality. The place belies its reputation, however, retaining a true multi-ethnic character and strong community spirit despite the disruption of modern redevelopment. The residents originally came from over fifty different countries and contribute richly to the cultural and racial diversity of the city and of Wales. Dame Shirley Bassey, 'the girl from Tiger Bay', became a much-loved superstar, one of many celebrated characters from the Bay.

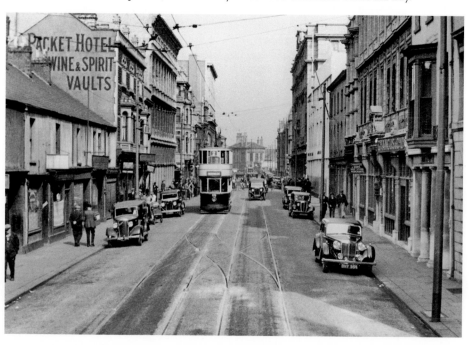

At the shopping precinct about halfway along Bute Street, an incredible work of street art immortalises Butetown's history. The 'Loudon Square Mural' (*sections shown below*) was created in 2008 by artist Kyle Legall and took 111 days to complete using 450 cans of spray paint! Measuring over 500 feet, it's one of the longest murals in the UK. The work depicts many of the characters of Tiger Bay and chronicles significant events in Butetown's rich history as well as honouring the area's merchant seamen and their wartime sacrifices. The colourful work celebrates the vibrancy and diversity of this special part of Cardiff and is currently being incorporated within the new development taking place.

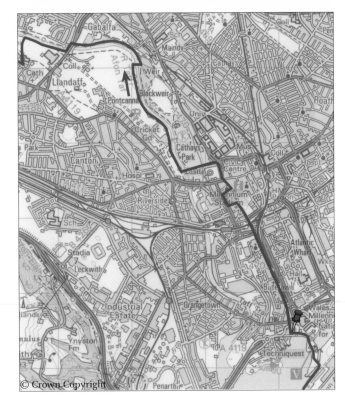

© Crown Copyright

The route continues to the end of Bute Street and under the railway bridge, passing to the right of the Golden Cross Inn, which is a listed building. The pub has a fascinating interior, with tile pictures of Cardiff Castle, Brains Old Brewery and the old town hall.

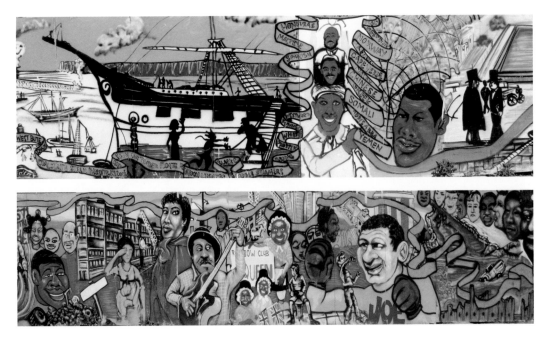

31

Passing the smart St David's shopping centre and John Lewis department store, we reach the splendid new Cardiff Library with its futuristic sculpture (*left*). Looking ahead along The Hayes, the picture (*below*) shows the view in 1920, with David Morgan's department store on the left and the old library in the distance. Today's scene epitomises Cardiff's growth into a fine modern city. Once an ancient Roman fortress, Cardiff survived attacks by Vikings before being settled by the Normans for their castle stronghold, built on the site of the old Roman fort. Cardiff gradually developed as a port with wool and iron trading through its harbour from the sixteenth century onwards. It was coal that became king, however, leading Cardiff to become a great commercial centre in the nineteenth century. The Cardiff of today is a booming capital city, with its regenerated bay area linked to a dynamic city centre.

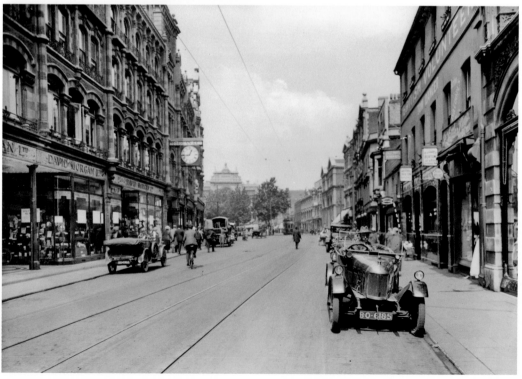

Moving along The Hayes, before reaching St David's Concert Hall (ahead on the right), the Royal Arcade leads left into St Mary Street. Cardiff is famous for its historic arcades, which form an atmospheric part of the shopping area, and the Royal Arcade is the oldest of them, built in 1856. The photograph (*right*) was taken in around 1914.

St Mary Street is well worth exploring and is probably the city's most well-known thoroughfare. The busy scene (*below*) shows the street from its southern end around 1900, with trams and horse-buses much in evidence. Nowadays, the street really comes alive on rugby international days, with the Millennium Stadium nearby and the hostelries hosting singing and revelry, particularly after Wales have won!

Turning right along the street with the castle ahead, the walk route turns right again at the market entrance into Cardiff's indoor market. The Castle Arcade across the street offers a pleasant diversion leading towards the castle entrance.

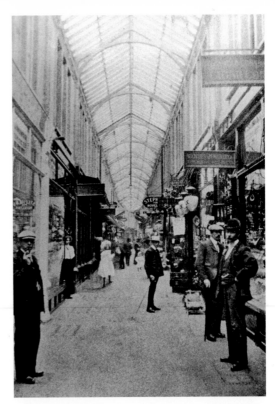

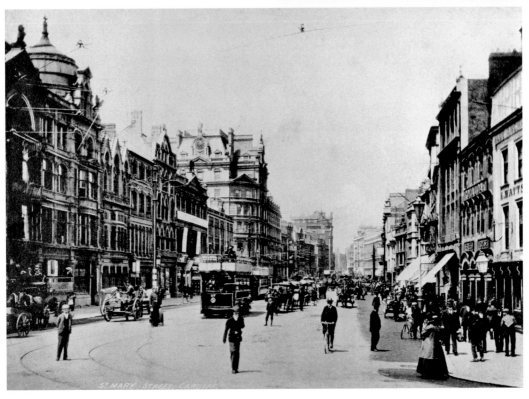

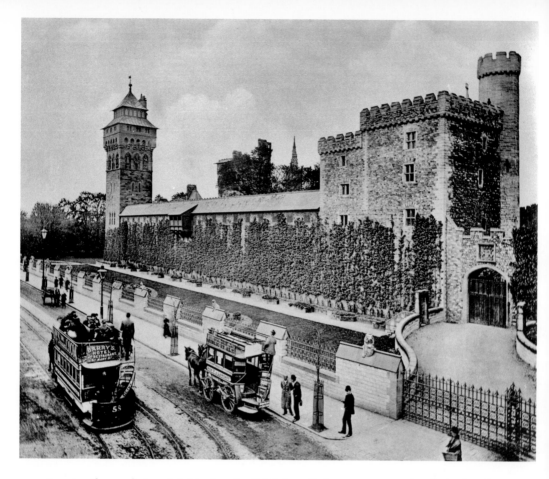

Leaving the market past Ashton's splendid fish stall, the route passes St John's church to reach the corner of Cardiff Castle. The photograph (*above*) shows a horse-bus and horse-drawn tram outside the castle in around 1896. The much-loved 'animal wall' was moved further west in the 1920s.

The castle's 2000-year history mirrors that of the city itself. The Romans established their first fort here around AD 60 after they had finally subdued the Silures. This was the lowest crossing point of the River Taff, whose original course contributed to the strategic position of the fort, with its access to the sea. The Norman castle was founded on the site by William the Conqueror in 1081 when the elevated motte was created, the impressive stone-built keep being added in the twelfth century in response to the Welsh uprising. Owain Glyndwr attacked the town and castle in 1404, and the castle was later badly damaged in the Civil War.

The 1st Marquess of Bute acquired the estate in 1766, and the castle and adjoining mansion were transformed with 'Capability' Brown designing the layout. The castle became a Victorian Gothic masterpiece when the fabulously rich 3rd Marquess engaged William Burges to create the beautiful interior restoration seen today. The castle walls were rebuilt on their Roman foundations and incorporated internal galleries to allow the Marquess to exercise in bad weather. These 'tunnels' were used as air-raid shelters in the Second World War and are fascinating to visit, as is the remainder of the castle.

34

Passing to the right of the castle, the route reaches the magnificent civic buildings at Cathays Park. The picture (*above*) shows the Law Courts and the clock tower and dome of City Hall with the National Museum behind. These may be visited via a subway, but our walk route goes left alongside the castle walls into Bute Park. The castle and park were gifted to the people of Cardiff by the 5th Marquess of Bute in 1947, providing a delightful haven of peace in the heart of the city. Our path reaches the River Taff, crossing the footbridge to join the Taff Trail, turning right and following the west bank of the river. After the National Sports Centre and SWALEC cricket stadium, the riverbank is followed before crossing Blackweir footbridge and continuing on through a subway under the A48. Crossing the road bridge here, the route rejoins the river's west bank before a path leads left to Llandaff Cathedral, the west front of which is pictured (*right*) in 1898.

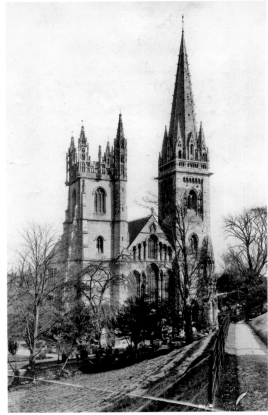

The glorious cathedral of the ancient 'City of Llandaff' stands on one of the oldest Christian sites in Britain, dating from the sixth century. Dedicated to Saints Peter and Paul, and to three Celtic saints – Dyfrig, Teilo and Euddogwy – the present building dates from the early twelfth century. The cathedral was heavily damaged by a German mine in 1941 and its later restoration included the great arch between nave and choir surmounted by Sir Jacob Epstein's imposing *Christ in Majesty*.

Walking from the cathedral up to the attractive cathedral green, the ruined Bishop's Castle gatehouse on the left leads to a peaceful little garden. The cross on the green traditionally marks the place where Baldwin, Archbishop of Canterbury, preached when accompanied by Giraldus Cambrensis on his great journey through Wales in 1188 recruiting for the Third Crusade. Crossing paths here with Giraldus gives a real sense of history.

A splendid nearby place of refreshment is the Butchers Arms, just along the High Street. Built in 1820 as a 'gentleman's residence', it became a butcher's shop before being acquired by William Hancock's Cardiff Brewery around 1900. It has traded as a pub for over a century and has much character – the many rugby-related pictures adorning the walls give a clue as to the pub's clientele. The watercolour (*below*) shows the pub with the cathedral spire in the background.

Across from the Butchers Arms, just along the High Street, there's a plaque on the wall of the Chinese Takeaway inscribed 'Roald Dahl, Author, Born 1916 Llandaff, Died 1990 – Site of "Mrs Pratchett's" sweetshop during his time at Cathedral School as recalled in his autobiography *Boy*'.

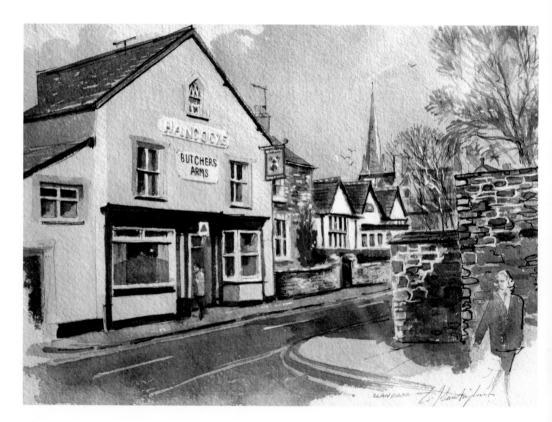

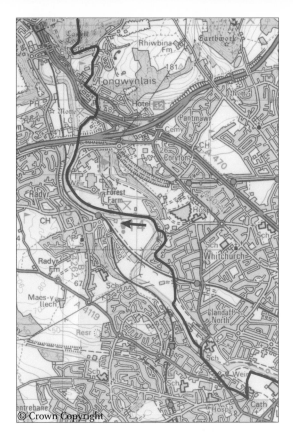

From the Cathedral Green the route continues along Bridge Street to join the main road, bearing right on Bridge Road and passing the BBC studios on our left. After passing the entrance to Llandaff Rowing Club, the road leads to Llandaff Bridge. Crossing over the bridge, the Taff Trail is rejoined on the east bank of the river. The Cow and Snuffers pub 200 metres ahead was built alongside the Glamorganshire Canal and was once frequented by Benjamin Disraeli.

The Taff Trail passes through Hailey Park; the charming view (*below*) of the old Llandaff Bridge was taken looking southwards from here in 1891. The bridge was originally built in 1770, later widened, then finally demolished and replaced by the present bridge around 1980.

Continuing northwards, the Taff Trail turns right, away from the river, passing left along Ty Mawr Road to the interesting restored Melingriffith Water Pump. The 200-year-old pump once pumped water back into the canal from a nearby tinplate works.

© Crown Copyright

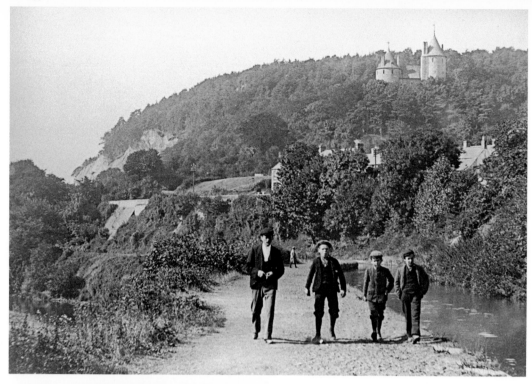

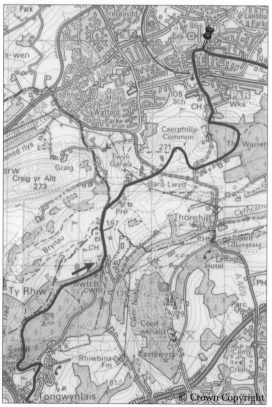

The Taff Trail turns left here to rejoin the river, which it follows around past Forest Farm before passing under the M4 motorway. It then turns right near the old iron tramway bridge and continues along Ironbridge Road towards Tongwynlais. The Trail passes under the A470 trunk road, which has now obliterated much of the line of the old Glamorganshire Canal. The canal ran for 25 miles from Merthyr to Cardiff and was busy with iron and coal barges in the early 1800s until superseded by the railway. The canal scene (*above*) was pictured near here about a century ago and shows Castell Coch in the background.

In Tongwynlais, the Trail turns right along Mill Road then left at the entrance to Castell Coch, up the steep drive. The 'Red Castle' is a Victorian fantasy built on the old foundations of a medieval fortress. Having transformed Cardiff Castle, the 3rd Marquess of Bute again collaborated with William Burges and work started here in 1875. Sadly, Burges died before its completion.

With its three great towers overlooking the Taff Gorge, Castell Coch is now looked after by Cadw and amply repays a visit. There was once a vineyard here and the winery at Cardiff Castle produced decent wine, despite predictions that 'if ever a bottle of wine were produced it would take four men to drink it – two to hold the victim, and one to pour it down his throat'!

From Castell Coch, the Taff Trail ascends steeply through the woods; but where the Taff Trail turns sharply left, we continue straight ahead through Fforest Fawr. The route emerges on a lane, turning left to reach the old Black Cock Inn, where we fork right. Continuing to the T-junction, the route goes straight ahead across the road and up the hill to reach the trig point on Caerphilly Common. This first great viewpoint of the walk has a plaque aptly saying, 'O Lord, how manifold are thy works, in wisdom hast thou made them all: the earth is full of thy riches.' Descending ahead briefly, the preferred path then contours back around to the right to head for the popular snack bar over in the distance. (The more direct route, angling downwards to the corner of the golf course, can become overgrown and boggy.)

To avoid walking down the main road, we take the bridle path from the corner of the snack bar car park, passing a house and then forking left down through the woods. Near the bottom, a path leads off left to join the main road into the town of Caerphilly. We soon reach the magnificent castle (*below*) with its 'Green Lady' ghost!

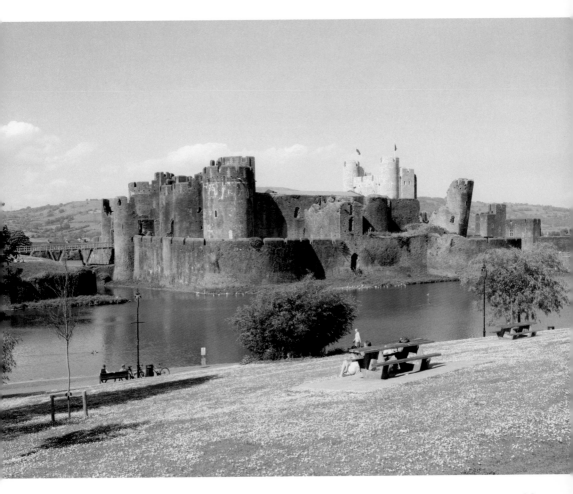

Chapter Five

Caerphilly to Cwmcarn

13.9 miles (22.4 km)

'Half a league onward!'

Caerphilly is where our path coincides with a great traveller from the past, George Borrow, who walked through 'Wild Wales' in 1854. He 'reached Caerffili at about seven o'clock, and went to the 'Boar's Head', near the ruins of a stupendous castle, on which the beams of the moon were falling'.

Caerphilly became a Roman fortress after fierce resistance from the Celts, later becoming part of the kingdom of Morgannwg. It took the Norman invaders two centuries to prevail against the local hill tribes, and the great castle was built in 1271 by Gilbert de Clare as a statement of his power. The ghost of his bride, the 'Green Lady', is said to still haunt it. It's said that, during the Civil War, the castle was blown up with gunpowder by Cromwell's troops, resulting in its iconic leaning tower. The industrialisation of Caerphilly followed later, with coal-mining expanding in the nearby valleys. The price paid for coal was far too great – at Senghenydd Colliery, 520 miners were killed in the appalling disasters of 1901 and 1913.

Caerphilly has long been a town of markets and fairs – the annual Big Cheese festival still celebrates the local cheese once beloved by colliers. The excellent 'Visit Caerphilly' centre at The Twyn welcomes visitors from all over the world and its imaginative modern design and setting contrast with the scene of over a century ago (*below*).

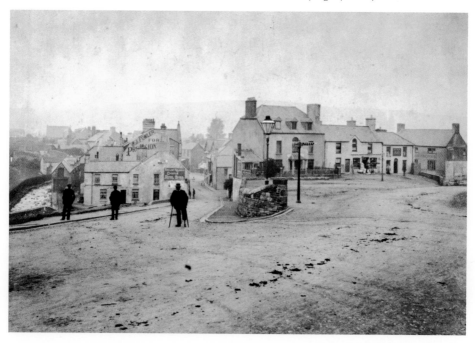

The photograph (*opposite below*) shows 'Pegleg' Fullalove at The Twyn in around 1897. Most of the buildings have been demolished, but Borrow's 'Boar's Head', on the extreme right, still survives.

One of Caerphilly's most famous sons is Tommy Cooper, born in the town in 1921. Described as 'the funniest British comedian of all time', his statue on The Twyn (*right*) was unveiled by actor Sir Anthony Hopkins in 2008.

Today's walk follows the Rhymney Valley Ridgeway Footpath to Machen before climbing Mynydd Machen and descending into the Ebbw valley. The route leaves The Twyn to head east along Van Road, continuing along the Rudry road then turning left into the Coed Parc-y-Fan car park. A forest track leads straight uphill, before going left then right to reach Rudry Common. It's interesting to recall Borrow's impressions when leaving Caerphilly. After passing through a tollgate, he 'ascended an acclivity' from the top of which he obtained a full view of the castle 'looking stern, dark and majestic'.

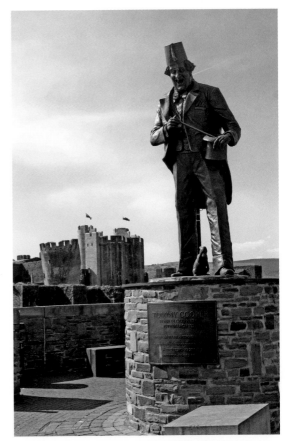

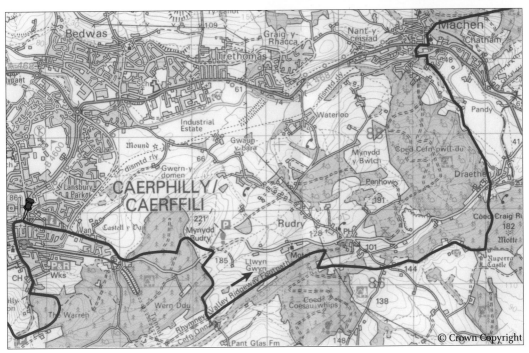

© Crown Copyright

41

From Rudry Common car park a lane opposite angles up to Cefn-onn Farm to join the Rhymney Valley Ridgeway Footpath. Heading left along this classic ridgeway route, there are airy views and undulating wooded countryside to enjoy. The footpath is waymarked and bypasses Rudry village before leading on to the 'romantic ruin' of Ruperra Castle, which was built on an earlier medieval site in 1626. King Charles I stayed here during the Civil War, raising support after his army's defeat by Parliamentary forces at the Battle of Naseby in 1645. Although destroyed by fire in 1783, the castle was rebuilt with its distinctive battlements, and Godfrey Charles Morgan, later Viscount Tredegar, was born here in 1831. In 1854, as a captain in the 17th Lancers, he commanded a section at the Battle of Balaclava that rode into the 'Valley of Death' in the Charge of the Light Brigade, immortalised in Tennyson's great poem, which begins, 'Half a league, half a league, half a league onward'. Ruperra became a great Victorian country estate, but later its fortunes declined. In December 1941, the Castle was again destroyed by fire while British troops were billeted there – on the same night as the Japanese attack on Pearl Harbor. The image (*above*) shows Ruperra in the 1930s, pre-fire, as seen from the north-west gate. After the war, the estate was sold off and remains private property.

From the castle, the path goes left over Coed Craig Ruperra before emerging from the woods above the pleasant little village of Draethen and descending towards its 200-year-old Hollybush Inn.

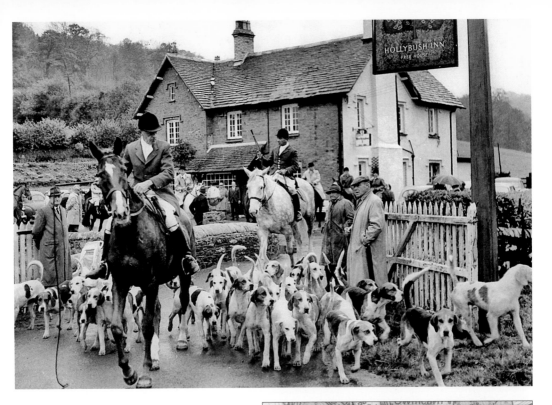

The Tredegar Hunt (*above*) leaves the Hollybush in the 1960s, led by Bert Molyneux, Master of the Hounds. The Hollybush has a charming country setting with a little bridge over the stream in front and welcoming log fires in winter. An annual Balaclava dinner was once held here for the Tredegar Estate employees, honouring the daring deeds of the battle.

The footpath continues opposite the pub entrance, through a conifer plantation, reaching the lane leading to Machen. Just past Rhyd-y-Gwern Farm, a stile on the right takes the field path to Machen village.

Borrow came this way around the time of Balaclava, describing the scenery as very beautiful, but 'to a certain extent marred by a horrid black object, a huge coal work, the chimneys of which were belching forth smoke of the densest description'. He was probably describing Machen Forge and Colliery, a little further up the valley. The remains are worth a detour on the Machen Forge Trail.

© Crown Copyright

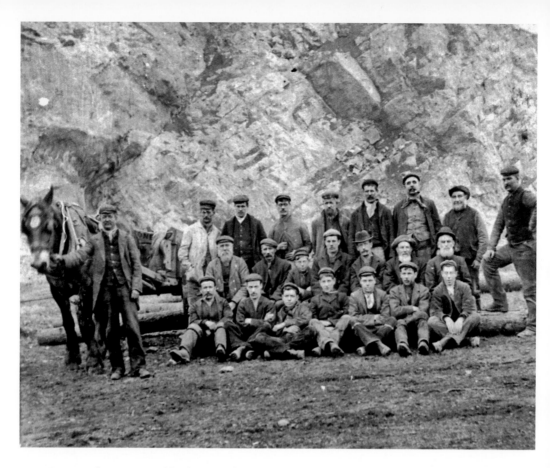

Crossing the Forge Road bridge over the Rhymney River and up to the main road in Machen, the route turns right to the Fwrrwm Ishta pub then left up Church Street past St John's church, where Harry Secombe's brother Fred was once rector. The village has left its iron and coal past behind and all is peaceful as the footpath veers right to ascend through the woods to Mynydd Machen. Climbing upwards, the views open out and the huge Machen Quarry appears. Limestone has probably been quarried here since the eighteenth century, when the stone was burned in limekilns to produce lime for the land. In more recent times the quarried stone has been used for construction and as a flux for steel-making. The picture (*above*) shows a group of hardy Machen quarry workers in 1908.

The TV transmission mast at the top is the goal, and upon reaching it there are stunning views. The city of Newport and the Ebbw valley are below and the Severn bridges are visible in the distance. It's exhilarating to look back on the route travelled so far, to see Flat Holm island, Cardiff Docks and Caerphilly Common.

One wonders at the views seen here by the Bronze Age people who created the burial cairn known as Begwns Round Barrow on the summit mound, where the trig point now stands. How different it all must have looked three thousand years ago.

The area towards the quarry is known locally as the 'Devil's Apron Strings' after a legend about St Peter chasing the Devil and throwing huge boulders he carried in his apron. Apparently, many of them landed on Mynydd Machen! The massive bonfire (*right*) was built on the summit to celebrate the coronation of King Edward VII in 1901. The material was carried up the mountain by mule and the bonfire was one of many lit across the country.

The route continues with the Ebbw valley stretching ahead (*below*), passing a very large coal tip, now grassed over, on our left. The spoil from North Risca Colliery in the valley was hauled up the mountain by ropeway to produce this stark reminder. The footpath here is shared with the Sirhowy Valley Walk; and as the track heads westward, the Sirhowy Valley appears below. This was the location of the Nine Mile Point Colliery at Cwmfelinfach, so named due to its distance from Newport via the Sirhowy tramroad.

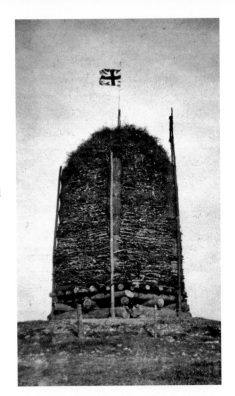

There was a 'stay-down' protest at Nine Mile Point in 1935 over the use of 'scab' labour. 164 miners stayed underground for 177 hours until the mine owners agreed not to use non-federation labour. Happily, the scars are healing and the valleys are becoming green again. Modern housing is interspersed among the earlier mining terraces, and new industrial sites have replaced the former collieries.

Leaving the Ridgeway footpath by turning right where it meets the lane near Twyn Gwyn, the track forks left at a cattle grid to descend through the woods to the Sirhowy Valley Country Park office at Full Moon. Crossing over the old railway track here, the Sirhowy River is reached and the route follows the riverbank and crosses a footbridge before passing under the highway to head towards Crosskeys.

The North Risca Colliery was once near here but all trace has now gone. The pit was sunk in 1875 to mine the rich Blackvein seam. Because of the gaseous nature of the seam, pits that worked it were called 'fiery pits', and on 5 July 1880, 120 men and boys were tragically killed in a gas explosion. The force of the blast was so great that it badly damaged the ventilation fan, thereby delaying the rescue effort. The picture (*below*) shows the colliery in the early 1900s, viewed from the east. It was closed in 1967.

The Monkey pub (currently boarded up) was once called the Tredegar Arms, apparently renamed after a man with a monkey played the piano here. On a more sombre note, the colliery disaster inquests were held here in 1880. The route turns left here to a subway with a remarkable mural.

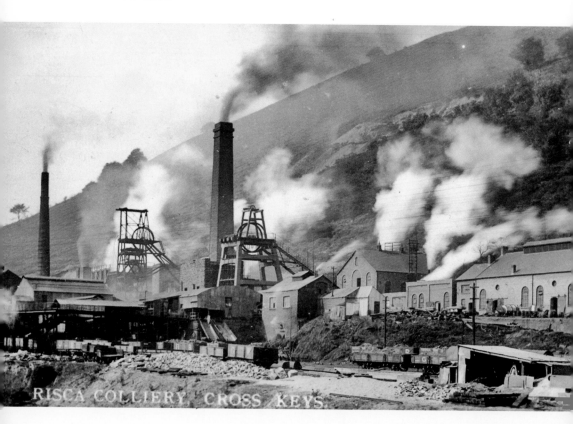

RISCA COLLIERY CROSS KEYS.

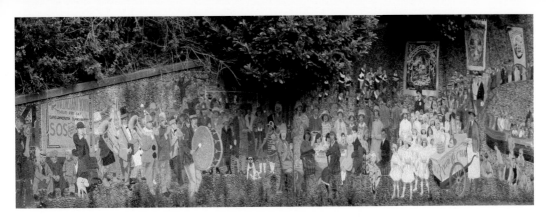

The mosaic (*above*), by Kenneth and Oliver Budd, depicts earlier times in the valley – the circus band, the tea party, rugby players, the Sunday school 'Band of Hope' temperance march, ice-cream seller and a canal boat outing. Further under the bridge is another mural with a coal-mining theme, including an old man whose 'tools are on the bar' looking reflectively at the pithead. Continuing towards Pandy Park, home of Crosskeys RFC, the route turns right to cross over the River Ebbw and through another subway to reach the centre of Crosskeys. The spot near the railway bridge was once known as 'Penniless Corner', where the unemployed gathered in the 1920s (*below*) – a similar image is depicted on the left-hand edge of the mural. After turning right on the main Risca road for a short distance, the route heads left along a narrow footpath that leads between the houses and over an old footbridge up to the canal towpath.

The Crumlin Arm of the Monmouthshire Canal was opened in 1799. It was quite a feat of engineering – the 11-mile stretch from Newport to Crumlin had over thirty locks. The tranquillity here is welcome as the towpath leads north past Coed Mamgu (Granny's Wood). After Pontywaun Bridge the canal runs alongside the main road towards Cwmcarn, where it now ceases.

The hill between Pontywaun and Cwmcarn is known as 'Factory Trip' and the scene (*above*) shows the canal and Cwmcarn lock in around 1920 with the Nant Carn valley off to the right. The canal aqueduct and road bridge over the Carn stream were once separate structures with a small cottage in between. These were all swept away in 1875, when the earth dam of the canal reservoir further up the valley gave way, sending death and destruction flooding down. Twelve people were killed, including the Davies family of three in the cottage and nine at the nearby woollen mill.

Leaving the canal here to cross the road, the way goes down Brookland Terrace, then up some steps to the football field to pass along Feeder Row towards the Carn valley. Passing the children's playground, a narrow path turns left up to Nantcarn Road. This is the approximate spot where the dam broke. A right turn along Nantcarn Road leads on up to the new visitors centre at Cwmcarn Forest Drive and Mountain Biking Centre.

Cwmcarn to Pontypool

9.9 miles (15.8 km)

'From the hills of Gwent I saw the earth'

Today we walk through the scenic Cwmcarn Valley on part of the Raven Walk before climbing up to the airy hill fort of Twmbarlwm, then across the mountain into the Eastern Valley to arrive at Pontypool, 'the cradle of Welsh industry'.

Cwmcarn Visitors Centre has an attractive information area, shop and café. From the outdoor eating area at the rear, the path runs above the Nant Carn stream, continuing along the left-hand side of the lake. Just above the lake to the left was the site of Cwmcarn Colliery, which at its peak employed over 700 men and produced 1,000 tons of coal a day. It's difficult to imagine that the lake was once the site of railway sidings and a coal-screening plant.

Charcoal was produced in this valley in the seventeenth century and coal-mining first started here in 1836. The colliery closed in 1968 and its buildings were demolished in the early 1970s. The Forest Drive road now passes over the filled-in pit shafts and a monument marks the spot. (A car journey around the Forest Drive is recommended – there are spectacular views from seven different parking areas with magical wooden sculptures of giants, wizards and totem poles.) The forest is very popular with mountain-biking enthusiasts, who travel from far and wide. The Twrch Trail is a particularly demanding biking route, named after the fierce wild boar of the *Mabinogion*.

© Crown Copyright

The picture (*left*) shows the transformed landscape of the lake. From here our walking route continues along the lane and soon bridges over the stream. Just before a barrier, the track goes right uphill through a gate with a signpost to Twmbarlwm. As we climb up through the forestry on the Raven Walk, the footpath leads up to Pegwn-y-Bwlch car park, where a wooden statue of a walker and dog represents the Search and Rescue Dog Association. Here, we leave the Raven Walk to climb steeply up to Twmbarlwm hill fort. At the bottom of the climb is a statue (*below*) depicting the raven and the book of the *Mabinogion*, which is a collection of fantastic stories from Celtic mythology, compiled from medieval Welsh manuscripts. Twmbarlwm is an Iron Age hill fort with double defensive ditches, probably established by the Silurian Celts. The steep climb up to it is rewarded with magnificent views.

The view takes in the city of Newport with its iconic transporter bridge and much of the fair county of Gwent. The Severn Estuary stretches away into the distance and the view perhaps inspired Newport's tramp poet W. H. Davies to write his evocative lines:

Can I forget the sweet days that have been,
When poetry first began to warm my blood;
When from the hills of Gwent I saw the earth
Burned into two by Severn's silver flood.

The mound at the eastern end is something of a mystery – it may have Roman or Norman origins but it's been suggested it was the burial mound of the horse that Lord Tredegar rode during the Charge of the Light Brigade!

The walk heads north-east along the ridge of Mynydd Henllys, with a great view of the Eastern Valley and the 'new town' of Cwmbran, which has grown from a few small villages. This was once the home of John Williams VC, hero of Rorke's Drift, whom we'll meet later.

The track passes forestry on the left, following the ridge before veering right on the edge of the hill to descend gradually towards Upper Cwmbran, dropping down into the attractive side valley of the Bran brook – the Valley of the Crow. The path zigzags down into community woodland, passing the old Blaen Bran reservoirs and reaching the historic group of houses known as The Square (*below*).

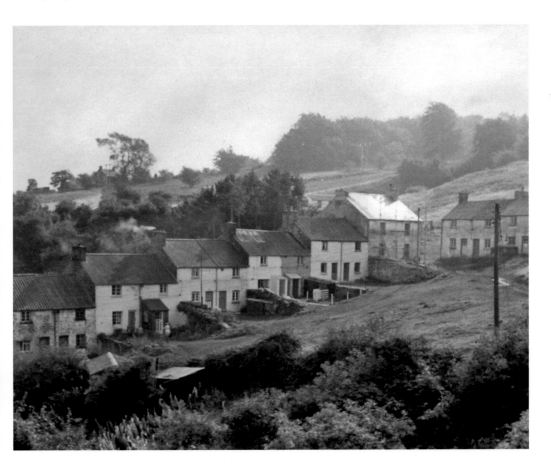

This is a fascinating area where the origins of Cwmbran began and it has much industrial history. Porthmawr Colliery began working coal and fireclay from the slopes of Mynydd Maen in 1837, and by 1843 the brickworks below The Square was producing 100,000 firebricks every week.

The Square was the heart of the community and its houses were built around 1840. Although some properties have been demolished, the remaining residents steadfastly continue to preserve the heritage of this special place. The houses are stepped due to the slope and the upper terrace included the Squirrel Inn, now sadly gone. The first school in Upper Cwmbran was established in an upstairs room of the inn in 1852 and accommodated over a hundred children, although the noise from drinkers in the bar below was much complained about by the headmaster! There was also concern about truancy among the boys, who clearly preferred playing on the incline to going to school. Some children were missing because they had gone to work underground, even though they were under ten years of age. The old photograph (*below*) shows a group, including children, outside the Squirrel Inn.

There were originally four pubs in the village – The Squirrel is long gone but The Bush survives. Similarly, The Crown has disappeared but The Queen still reigns (it's said that the Queen lost her Crown in the Bush!). Walking down to the road junction (also the bus terminus), the Bush Inn is around to the right and The Queen is down ahead, with its attractive garden featuring ducks on the Bran brook.

The community's three chapels always urged temperance – Ebenezer and Siloam still remain while Bethel is now a private residence.

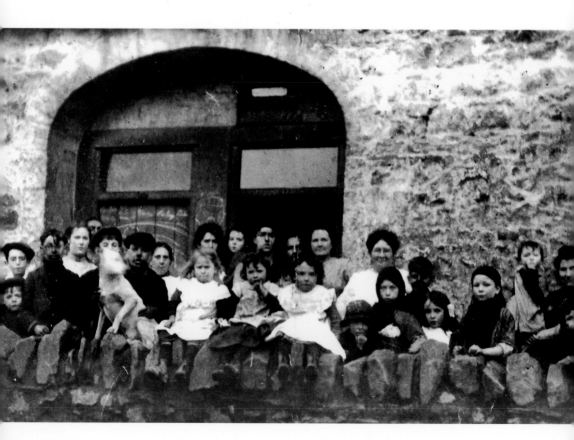

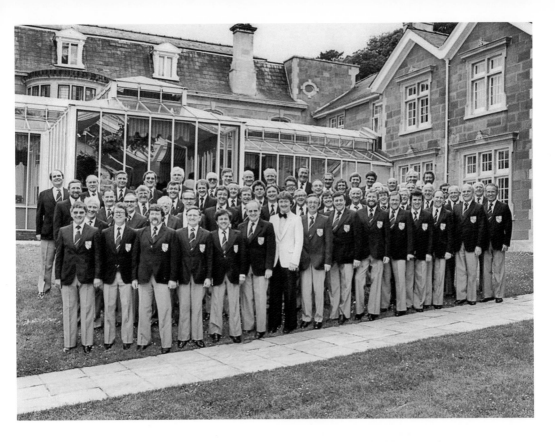

Siloam chapel has been holding services since 1838, playing an important part in Upper Cwmbran's rich cultural history, with its choirs and competitions. In 1904 a meeting was held at the Bush Inn at which the Upper Cwmbran United Male Voice Party was formed. The choir later became known as the Pontnewydd Male Choir and is still going strong after more than a century. Another local choir with its roots in Upper Cwmbran is the Cwmbran Male Choir, pictured (*above*) at the official opening of the Celtic Manor Hotel in Newport in 1982. This was the beginning of the extraordinary development by Sir Terry Matthews that was to bring the Ryder Cup to Wales in 2010.

Our route from the junction goes up the lane past Siloam chapel and the lovely old sixteenth-century farmhouse of Glyn Bran that once had a cider mill. The lane is an ancient highway and leads steeply up to the aptly named Mountain Air Inn.

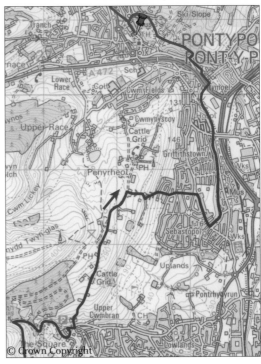

The mountain road has great views. Half a mile along from the Mountain Air, the route turns right down Cwrdy Lane dropping steeply around a sharp left bend. The route continues down to eventually turn right down Greenhill Road, reaching the Crown Bridge over the canal. We're now in Sebastopol, named after the city besieged during the Crimean War. The siege of Sebastopol in 1854–55 lasted 364 days before the 'City of Glory' finally fell.

The Monmouthshire Canal is now followed northwards and the towpath soon passes the Open Hearth pub, whose name recalls the nearby Panteg steelworks. The pub used to receive deliveries of beer by barge from Newport and was called the Railway Hotel. In 1960, the brewery decided to change the name and held a competition to find a new name. A local steelworker won a barrel of beer for his entry!

The open hearth furnace at Panteg works is shown (*below*) being tapped in 1958. Steel was produced using this process for almost a century. In 1971 a revolutionary electric arc furnace was installed to concentrate production on stainless steels for many products, including beer kegs – perhaps some of these found their way to the pub. Sadly, the valley's last steel-producing plant closed in 1996.

The canal continues through Griffithstown, which has a proud railway heritage and in 1880 was the birthplace of the Associated Society of Locomotive Engineers and Firemen (ASLEF).

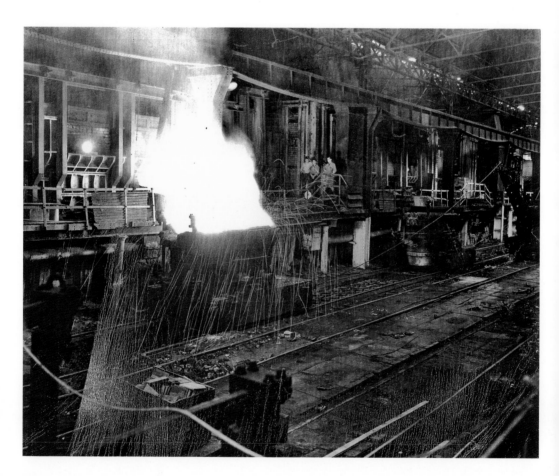

This is the main line of the
Monmouthshire Canal, opened in 1796.
The towpath continues to Pontymoile
Basin where the Monmouthshire joins the
Brecon & Abergavenny Canal. Tolls were
charged along the route and Junction
Cottage (*above*) was one such tollhouse
built in 1814. The presence of pleasure
boats at Pontymoile reminds us that
nowadays the canal provides a popular
leisure facility.

Reluctantly leaving the canal (for
now), our route follows Fountain Road
around into Pontymoile, before turning
left then right and crossing the road with
care to enter Pontypool Park through its
impressive ornamental gates.

The park is home to Pontypool Rugby
Club, whose fame echoed around the
rugby world, particularly during the 1970s
when coach Ray Prosser produced one
of the greatest club forward packs of all
time. The exploits of the Pontypool front
row (Charlie Faulkner, Bobby Windsor
and Graham Price), with David Bishop
(*right*) at scrum-half, are legendary. Max
Boyce immortalised the 'Viet Gwent' in
song.

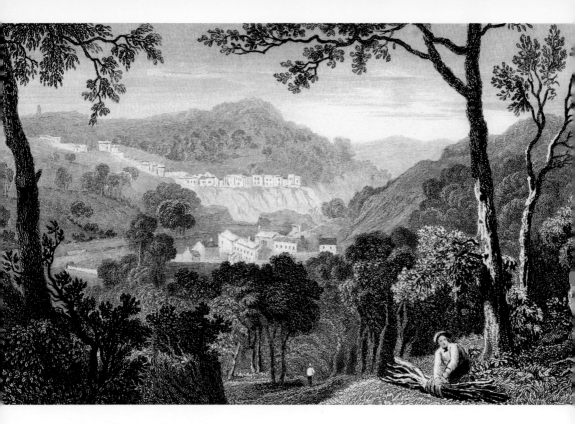

Pontypool's marvellous park was created in the late seventeenth century by the Hanbury family, ironmasters in the town, and followed the 'Capability Brown' model. The Shell Grotto summerhouse and the Folly Tower up the hill to the right are two of its most dramatic features and well worth the climb. The park was presented to the people of the town by John Capel Hanbury, the last squire of Pontypool, in 1920.

Ironworking was first undertaken here in the fifteenth century, and by the late seventeenth century the art of tinplating was perfected. The valley's wooded slopes provided charcoal to fuel the forges, and the rich resources of coal and ironstone led to Pontypool becoming one of the most prosperous industrial towns in Wales – a true cradle of Welsh industry. The engraving (*above*) shows charcoal collecting being carried out near Pontypool in the eighteenth century.

Passing to the right of Pontypool Park House (now St Albans RC school), the route reaches the old stable-block, converted into the splendid Pontypool Museum. The many exhibits include a display of the world-famous Pontypool Japanware – tinplate or papier-mâché 'japanned' with special lacquer and varnish, with elaborate decoration and mother-of-pearl inlay. Also to be seen is an interesting display telling 'The Story of Torfaen' and a fine collection of Vaughan clocks, made in Pontypool in the eighteenth century.

From the museum, the road turns left to cross the bridge over the Afon Lwyd or 'Grey River'. The fast-flowing river was described by an eighteenth-century traveller as a 'tor faen' or rock-breaker, this giving the County Borough its name. Pont-ap-Hywel (Hywel's bridge), after which Pontypool is named, was originally built in around 1425 and rebuilt for the National Eisteddfod held in Pontypool Park in 1924.

The Park Cinema was just on the left here but was destroyed by fire in 1970 (*right*). The film *Zulu* was showing at the time and it was suggested that the Zulus were having their revenge for the part played in the epic defence of Rorke's Drift by five Eastern Valley men! Privates John Jobbins of Pontnewynydd and William Osbourne of Blaenavon, Gunner Abraham Evans of Varteg and Corporal John Lyons of Pontypool fought valiantly alongside the valley's famous hero, John Williams VC.

Continuing left uphill, the main shopping street leads to the old town hall with another attractive entrance to the park opposite. Worth a visit is Pontypool's characterful indoor market, which dates from 1894, although there were thriving markets here at least a century earlier. A visitor of 1801 commented on the Welsh language spoken by the local folk and their distinctive costumes. One of the entrances of the market opens on to Crane Street, shown (*below*) in the early 1900s.

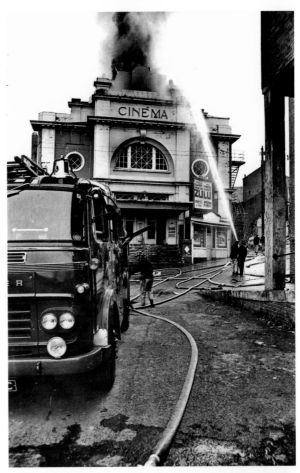

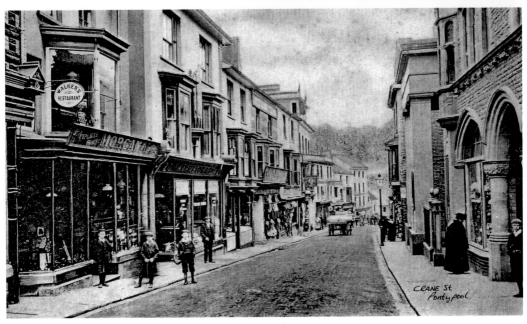

Pontypool to Blaenavon

10.9 miles (17.5 km)

How Green is my Valley?

Today we continue exploring Torfaen's Eastern Valley and its industrial history, leaving Pontypool town centre to walk up George Street. This leads to the cycle route that follows an old railway track up the valley, passing Cwmffrwdoer, Talywain and Garndiffaith before reaching the World Heritage Site at Blaenavon. A couple of detours include the site of Llanerch Colliery, the scene of one of the valley's most tragic mining disasters.

Although ironworking thrived in the valley from early times, coal-mining gradually overtook this. Collieries throughout the valley attracted workers from all over the country and Pontypool's population in 1841 was greater than Newport or Cardiff. The valley played an important role in the struggle for workers' democratic rights and featured prominently in the Chartist movement. The 'People's Charter' of 1837 sought six points: universal male franchise, voting by secret ballot, no property qualifications for MPs, payment for MPs, equal-sized constituencies, and annually elected parliaments. Most of these are now taken for granted, but at the time a mass petition for the Charter was rejected. On 4 November 1839, thousands of valley men rose up in protest. Large groups marched down the valleys towards Newport, and the Eastern Valley assemblage was led by William Jones of Pontypool. Jones's contingent didn't link up with the other groups as planned, but around 5,000 protesters, armed with sticks, pikes and guns, reached the Westgate Hotel in Newport where an ugly confrontation ensued.

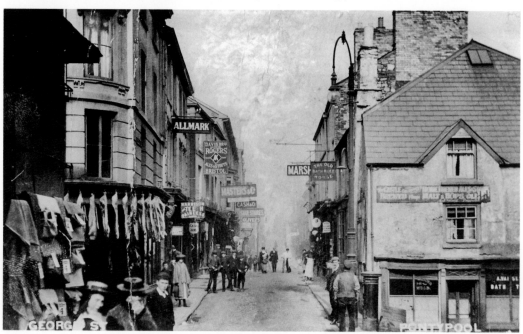

The redcoats were waiting for them and opened fire, killing twenty-two of the rioters, including George Shell, a nineteen-year-old carpenter from Pontypool. After the riots, William Jones (*right*) was arrested together with his co-leaders John Frost and Zephaniah Williams. The three leaders were convicted of treason at Monmouth Assizes and sentenced to death; but following mass protests, the sentence was commuted to transportation to Tasmania. William Jones was a watchmaker in Pontypool who also owned the Bristol Beerhouse near George Street, where he held working men's meetings to campaign against poor pay and working conditions. The NatWest bank now stands near the beerhouse site. The picture (*opposite*) shows George Street from the corner of Crane Street around 1900. The buildings on the right have been demolished and the street ahead is now pedestrianised, with a supermarket to the right.

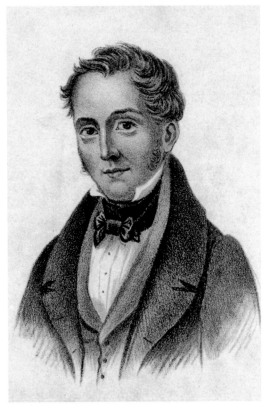

Walking up to the top of George Street, there's a subway under the bypass road with a mural commemorating 125 years of Pontypool rugby. After passing through the subway, the cycle track is joined, heading northwards up the valley. The railway that once followed this route was built in the 1870s – mainly for coal transportation, but it also carried passengers for a period.

The valley suffered heavily during the Depression years of the 1920s and 1930s, with much unemployment and hardship. The demand for munitions during the Second World War brought something of a recovery, other industries developing later, but the coal mines have all now disappeared. The valley is gradually regaining its former beauty.

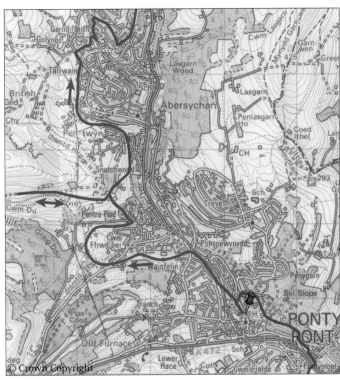

© Crown Copyright

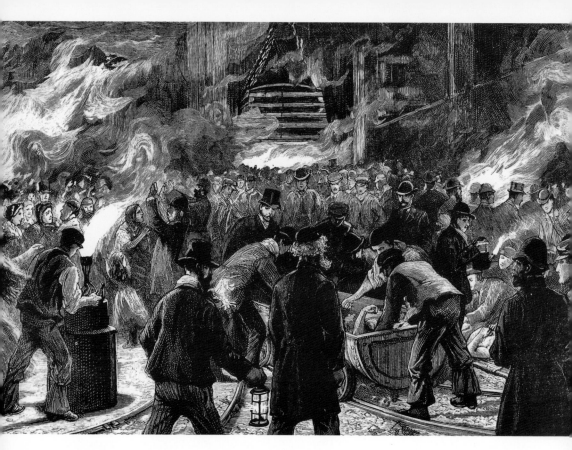

The cycle track follows a great loop around Cwmffrwdoer and Cwm Du, the valley of the 'Black Stream', which was the scene of a horrendous mining disaster on 6 February 1890. To visit the site of Llanerch Colliery, the route leaves the cycle track at Pentrepiod Road and goes left up the hill past Pontnewynydd Cricket Club (known locally as 'the Bat and Ball'). Turning left where the road turns right for Pentwyn, the lane continues straight on at a gate on a track leading to two fenced-off, filled-in mineshafts, opposite which a path zigzags up a bank to the memorial plaque.

The massive explosion killed 176 men and boys and was the result of naked flames igniting firedamp gas. An explosion two months earlier led to a recommendation by the inspector of mines that closed safety lamps be used in the mine, but this was disregarded as it was felt there was adequate ventilation – the managing director of the mine stated that 'at present we think that the colliery is well ventilated and safe to work with naked lights'. Few survived the explosion that devastated families in the area. The horror is conveyed in the picture (*above*) portraying the midnight shift waiting to descend the shaft to recover bodies. The mine was reopened just thirteen days later and continued operations until 1947. Just further along this valley was Blaenserchan Colliery, the last remaining coal mine in Torfaen, closed as recently as 1985. The valley is now green again and at peace, showing little sign of its industrial past when the two collieries employed over 2,000 men.

The route returns to the Pentwyn junction and turns left along the lane towards Pentwyn village, then right on a footpath to rejoin the cycle track. The track continues along the west side of the valley and, after Pentwyn village, crosses over the 'Big Arch', built to carry the railway in the 1870s. On the right here, the road going down towards Abersychan is known locally as 'Bob-a-day Hill' – apparently the men who built it were paid a shilling a day. This area has long been associated with ironmaking, which dates from at least the eighteenth century, when Abersychan iron was used to make cannons and cannonballs for wars as far away as France and America.

To the left of Big Arch are remnants of the huge British Ironworks, once a hotbed of Chartism. The British works was established in 1826 and soon became vast, with six blast furnaces, forges and rolling mills. It was supplied with coal from its own mines, and a village of workers' cottages was built on the hillside overlooking the works. There's only one row of cottages now remaining on 'The British', seen away to the left. The print (*below*) dates from 1866, when the iron products would have been hauled down the valley by horse-drawn tram to the canal. The works were closed by 1883.

Our walk leaves the cycle track at Talywain, passing the Globe Inn and turning right down Pisgah Road. Pisgah chapel here dates from 1827 and conducted services in Welsh, with bilingual services for the people who moved here to find work. It was the scene of a disturbance in 1872, when one drunken fellow shouted out during the English part of a baptism service, 'Don't give us none of that gibberish. Give it to us in Welsh!'

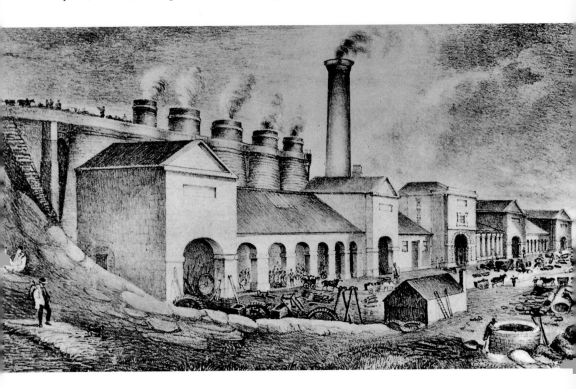

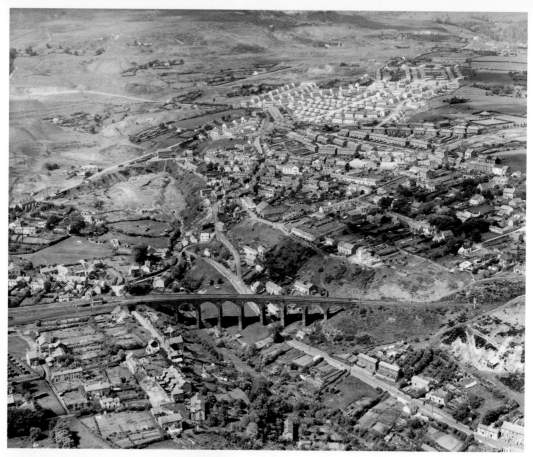

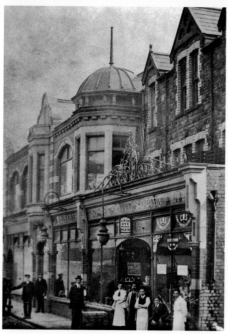

Pisgah Road goes downhill around a left-hand bend to cross the old bridge over the Ffrwd brook at the bottom. As we continue around right along Viaduct Road, there's a great view of the viaduct ahead. At a point about 150 yards before the viaduct, the route turns back sharply left uphill into the village of Garndiffaith. The aerial photograph (*above*) was taken in the 1950s: Talywain is bottom left, and the village of Garndiffaith top right. The viaduct was built in 1876 to carry the LNWR line to Blaenavon and Brynmawr. Passenger services ended in 1941 and the last mineral train from Big Pit Colliery in Blaenavon crossed it in 1980.

High Street, Garndiffaith has changed out of all recognition, the once tightly packed cottages and shops now replaced by modern housing and a car park. Turning right at the Hanbury Arms and continuing along Stanley Road, the route passes Garndiffaith Co-op, pictured (*left*) in 1909.

The Garndiffaith Industrial & Provident Society was founded by the local mining community in 1889, and the premises in Stanley Road first opened in 1908. For well over a century, the Co-op has provided services from 'cradle to grave' – including groceries, drapery, furniture, hardware and funeral services. Steadfast in times of crisis, it supplied food and clothes to miners and their families during the General Strike of 1926, mostly on credit. Many families also relied on the dividend or 'divi' paid out as a percentage of purchases. The legacy of Robert Owen, pioneer of the Co-operative movement, lives on.

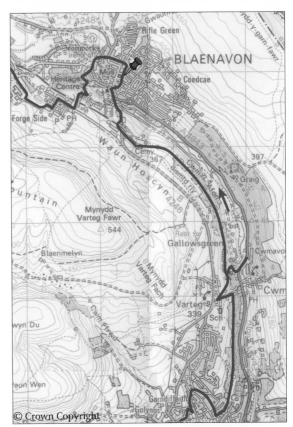

© Crown Copyright

Continuing along Stanley Road, with views of the post-industrial landscape across the valley, the road passes St John's church and a little triangular green, before bending down to rejoin the cycle track, on the right just before the bridge.

As we head northwards through woodland, a bridge over the track is reached after about a mile. Leaving the cycle track here to cross the bridge and follow the aptly named 'Snail Creep', we take the track leading up to Varteg Wesleyan chapel, now a Community Centre. Here is the final resting place of Gunner Abraham Evans, one of the heroic defenders of Rorke's Drift. He was in the hospital at Rorke's Drift mission station suffering from dysentery; but, with every man needed, he played his part in the desperate defence. He also survived the 96-day siege of Potchefstroom in the first Boer War, even though wounded by a bullet. Entering the graveyard through the kissing gate on the left, his headstone (*right*) is situated just before the chapel building on the right-hand side.

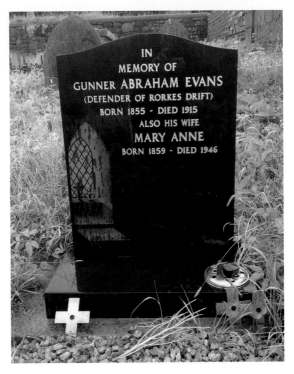

63

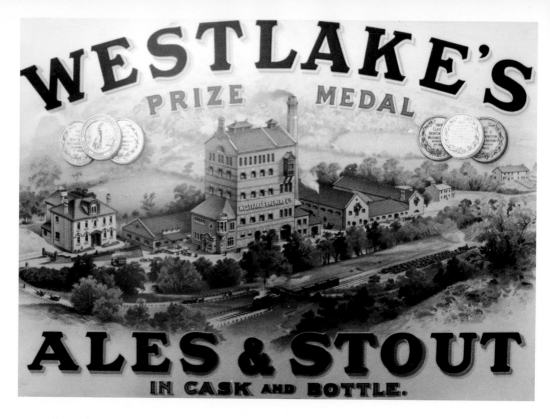

The cycle route is regained by dropping steeply down Shop Road, which reaches another bridge where the track may be rejoined. An additional short detour may be made by continuing downhill to Cwmavon to view some historic buildings. The road bends down past Old Shop Farm and two attractive cottages to reach the main valley road. As we turn left and carefully cross over the road, the Grade II listed Westlakes Brewery building may be seen. Built in 1900, the brewery was soon producing prize-winning ales to supply its estate of pubs. Trade later declined, however, and brewing ceased here in 1928. In the 1930s, during the period of mass unemployment, the buildings were used for a subsistence project, with a butchery and wool production centre that produced textile goods, including jerseys, ladies' garments and underwear. A plastics business now operates from the old brewery – the attractive poster (*above*) dates from 1910 and also shows the Low Level railway line.

A little further on is Forge Row, a superbly preserved row of early workers' cottages that was built in 1804 to house skilled workers at the nearby Cwmavon Forge. There were originally twelve cottages, now reduced to seven, and a plaque on the end wall relates some of the row's history. Forge Row has been described as the finest surviving terrace of early workers' housing in the South Wales valleys. The ironmaster's residence, Cwmavon House, is a little further along the road. After viewing the buildings, a short sharp climb back up Shop Road is required to rejoin the cycle track and continue towards Blaenavon.

The track soon arrives at the recently re-established Blaenavon High Level station, southern terminus of the popular Pontypool & Blaenavon Railway. The railway track has been restored from here to the Whistle Inn, passing Big Pit Museum – steam and diesel trains run on summer weekends (and other days). We leave the cycle track here, crossing the railway track with care, to follow the path down to join Varteg Road, descending into the town. The Low Level railway station once stood on the right at the bottom of the hill.

Blaenavon's industrial landscape was designated a World Heritage Site by UNESCO in 2000, 'bearing eloquent and exceptional testimony to the pre-eminence of South Wales as the world's major producer of iron and coal in the 19th century'. The site has undergone significant improvement and regeneration, and with its iconic logo (*right*) it attracts many visitors to the town. After crossing the Afon Lwyd, the Workmen's Hall and War Memorial are up ahead, photographed (*below*) in around 1960.

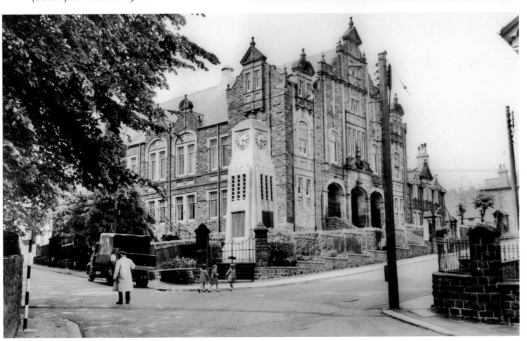

The Workmen's Hall was built in 1894, paid for by miners and ironworkers subscribing from their own wages. The hall has been a centre of learning and culture ever since, having served as a library, cinema and concert hall. There were once many such institutes in the valleys – this fine building is one of the few remaining. Across Church Road are St Peter's church and the World Heritage Centre.

The church was built by the ironmasters in 1805 and has many unusual cast-iron features in its construction as well as cast-iron covers on 'chest tombs' in the graveyard. The Heritage Centre occupies an old school building established by the same industrialists – during the Chartist Rising, the school was used as a barracks for redcoats. Now handsomely restored, the centre celebrates the important role Blaenavon has played from the dawn of the Industrial Revolution. Its displays and exhibitions tell a fascinating story, and the Tourist Information Centre is also situated here. As we turn around to walk up Broad Street, pictured (*above*) in 1905, there are a number of interesting buildings, including the imposing Moriah chapel, rebuilt in 1888. The chapels and strong temperance movement helped balance the influence of the town's public houses, said to have once numbered over seventy.

Further up Broad Street is the Lion Hotel, one of Blaenavon's first residential hotels, and undergoing refurbishment at the time of writing. This hostelry suffered badly during severe riots following the 1868 general election, when disturbances took place across the county. Townspeople incensed by the result turned on the Lion Hotel, smashing its windows, forcing their way in and helping themselves to casks of ale. The 'Free Press' reported that rioters 'went down on their hands and knees to drink like beasts until they reeled and fell senseless'. It took a detachment of Royal Welsh Fusiliers to bring a dangerous situation under control.

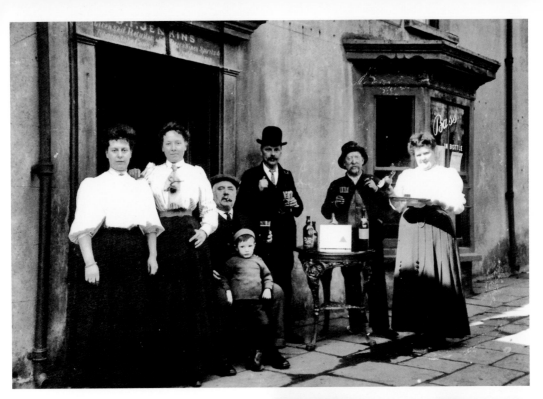

The group outside the Lion Hotel (*above*) are enjoying happier times a few decades later. Just along Lion Street is the town's modern library and excellent Community Heritage & Cordell Museum. The work of the famous novelist Alexander Cordell (*right*) is honoured here together with the history of the local community – the exhibits include Cordell's desk, typewriter and book collection. Cordell's evocative writing is vividly evident in his bestselling *Rape of the Fair Country*, which immortalised Blaenavon and the surrounding area. The powerful novel portrays the harsh conditions of the ironworks and forges, the bare-knuckle fights and riots, the chapels and beerhouses, and the characters and families caught up in the melting pot. The denouement features the hero Iestyn Mortymer's participation in the ill-fated Chartist march on Newport. Cordell's work is immaculately researched – it's no wonder he's often called 'the People's Remembrancer'. Many of the other locations in the novel are encountered in the next chapter.

Chapter Eight

Blaenavon to Abergavenny

11.4 miles (18.4 km)

Fair Country reborn

There's much of Blaenavon to explore and today's route includes the restored ironworks and award-winning Big Pit: National Coal Museum. The landscape of iron and coal is then left behind as we enter the Brecon Beacons National Park and the scenery changes dramatically. After a great viewpoint on the Blorenge mountain, the path descends to an old tramway and down to the canal at Llanfoist. The day's journey ends at the attractive market town of Abergavenny, often called the 'Gateway to Wales'.

At the top of Broad Street our route bears left along King Street (*below*), one of the town's oldest streets and previously known as 'Heol-ust-tewi' or 'Hush, Be Silent Street'. King Street leads on to North Street and the Blaenavon Ironworks, which once cast its great glow over the town. The ironworks is one of the most important monuments surviving from the early Industrial Revolution and commenced operations in 1789. Sited here to take advantage of plentiful supplies of coal, iron ore and limestone, it became one of the largest ironworks in the world. Much of the early works is preserved, including furnaces, cast house and foundry, and the impressive water balance tower. The workers' cottages and company shop at Stack Square have also been carefully restored and were the location for the popular *Coal House* BBC TV series. There was once a huge chimney stack at the centre of the square, hence its name.

The water balance tower was used to lift pig iron from the works up to Hill's Tramroad at the top of the bank. From here it was hauled through a 1½-mile-long tunnel to Pwllddu on the other side of the mountain, then on to Garnddyrys Forge for puddling to produce wrought-iron products. The picture (*right*) shows the balance tower with Blaenavon Town Band playing at the 2009 Cordell Festival that celebrated the fiftieth anniversary of the publication of *Rape of the Fair Country*.

Near the site's entrance is an obelisk and plaque marking the important contribution made by Sidney Gilchrist Thomas at Blaenavon in revolutionising the steel-making process. In 1878, with his cousin Percy Carlyle Gilchrist, he developed a method of removing phosphorus from pig iron which enabled mass worldwide steel production. The great American industrialist Andrew Carnegie stated that 'these two young men did more for Britain's greatness than all the Kings and Queens put together'.

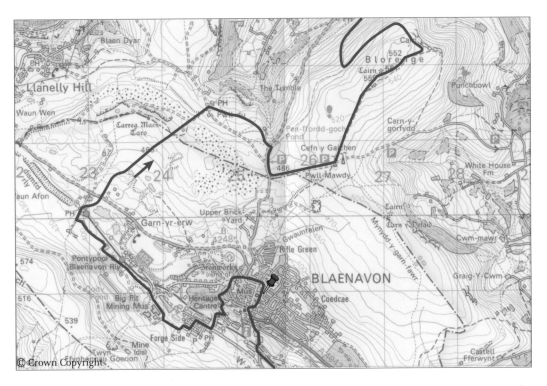

Blaenavon Ironworks prospered until the mid-nineteenth century then gradually declined as steel production developed over at Forgeside. Continuing downhill to Church Road and turning right, our route bends down and then up Forgeside Road, before turning right into Forgeside itself. The forge and steelworks were established here from 1859 and there's been an ongoing industrial presence since – notably the manufacture of precision forgings for aircraft engines, including those of Concorde. The rows of workers' houses here were lettered from A to E, and we turn left before turning right between E Row and D Row to continue around to Big Pit (*above*).

Big Pit was opened by the Blaenavon Company in 1880 and it soon became the largest coal-producing mine in the valley. It is estimated that around the turn of the nineteenth century the South Wales valleys had over 500 collieries, which employed over a quarter of a million people. The pit closed in 1980 after a century of operation, but its conversion to a museum has been a masterstroke. Visitors from all over the world get kitted up with helmets and lamps to descend the shaft to the coalface, where an ex-miner explains the working conditions underground. The total blackness when the lamps are momentarily switched off is profound. With its displays and superbly restored pithead baths, the museum is a must, especially as entry is free.

The path continues past Coity Tip, now reclaimed by nature, with the railway track to the right, eventually reaching the appropriately named Whistle Inn at the railway's present terminus. The LNWR line used to continue to Brynmawr and was built in 1866 to carry coal to the Midlands. It also carried passengers for a period, a pleasure now enjoyed by travellers on the Pontypool & Blaenavon Railway.

After we pass the pub and cross the old railway bridge, a path on the right leads us briefly into the Garn Lakes site, an attractive area reclaimed from the huge colliery spoil tips that once dominated the scene. Soon the route bears left to cross the main Brynmawr road, heading for Garnddyrys. The track leads up between some enclosures to the Dyne-Steel Incline – although initially a little indistinct, it follows a general north-easterly direction. The double incline over the hill to Garnddyrys Forge was steam-driven and in the 1850s replaced the horse-drawn tram road through the Pwlldu Tunnel, providing a quicker means of transporting pig iron to Garnddyrys Forge and bringing minerals and other goods from the canal in the other direction.

At the summit of the incline there are some stone remains where the winding house used to be and a magnificent view looks out over the Usk valley, with the Black Mountains to the left, the Sugar Loaf ahead and Skirrid Mountain to the right. The incline descends to Pwlldu, once a thriving village with over 300 residents, but only the Lamb and Fox pub and former welfare hall remain. The village once thronged with quarrymen, miners and ironworkers; but as the industrial workings declined, the houses were demolished and inhabitants relocated down the valley.

After crossing the road, the route turns off right through a kissing gate marked IMT (Iron Mountain Trail) leading to the old Balance Pond (now dry). As we move along the left side of the pond, the Pwlldu limestone quarry is just below, and way over on the bank to the right of the view are the strange slag remains of Garnddyrys Forge. The sketch (*above*) illustrates the scene as it once appeared.

This is real Cordell country – much of his novel's action took place against the backdrop of the red-hot puddling furnaces of Garnddyrys Forge. Our path veers right up to the road and Pen-ffordd-goch Pond, which was once a reservoir serving the forge. It's popularly known as Keeper's Pond, after the gamekeeper who kept the ironmaster's grouse and lived nearby.

Heading along the lane to the masts at Cefn-y-Galchen, the car park here is close by the grave of Foxhunter *(left)*, the horse ridden by showjumper Sir Harry Llewellyn when he won the gold medal at the 1952 Helsinki Olympics. From here the walk crosses the open mountain to reach the trig point at the summit of the Blorenge, continuing onward to the summit rim of the high north-east bowl of the mountain. Looking down, almost precipitously, towards the town of Abergavenny, the view is breathtaking *(below)*. It's easy to see why this spot is popular with hang-gliders.

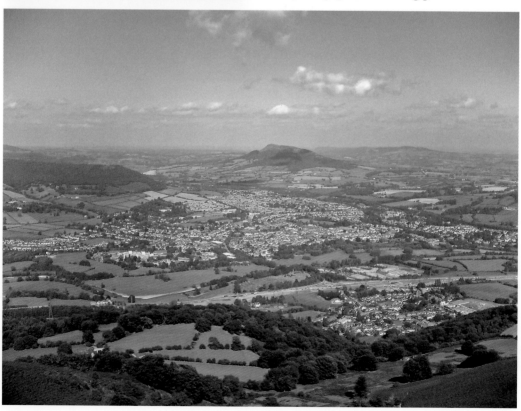

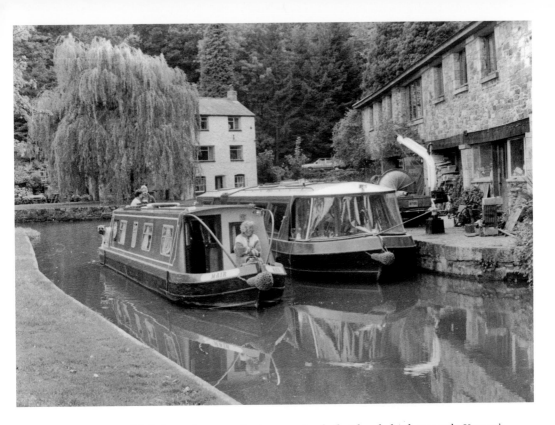

We move around left from the summit rim on a track that heads back towards Keeper's Pond. A bridleway then angles sharply right downhill. This meets the route of Hill's Tramroad, where we turn right. The site of Garnddyrys Forge is about three quarters of a mile back left along the tramroad. Also along there was the old Queen Victoria Inn, where in 1946 'a lively party caused the floor of the bar to collapse, depositing the clientele into the cellar below!' The tramroad was built in the 1820s to link the Blaenavon Ironworks with Garnddyrys Forge and the canal at Llanfoist Wharf. Stone sleepers can still be seen along its route. Coal, limestone and iron products were carried down to the canal, bringing iron ore (and beer from Llanfoist Brewery) in the other direction.

The track passes ruins at the site of the old Winch House under the hollow of the Blorenge. We then fork left at a fence corner to drop steeply down to the incline through the woods of Cwm Craf valley to the canal at Llanfoist Wharf. This was a three-stage incline and the full trams descended under gravity, pulling empty or lightly laden trams back up the hill. A pedestrian tunnel goes under the wharf house and canal, after which there are steps leading up to the towpath. The attractive scene (*above*) shows Llanfoist Wharf with a couple of cruisers next to the Boat House, once a warehouse for goods handled here. Today's tranquil scene belies the frantic industrial activity of the past, when the canal was the export route from Blaenavon ironworks to the world.

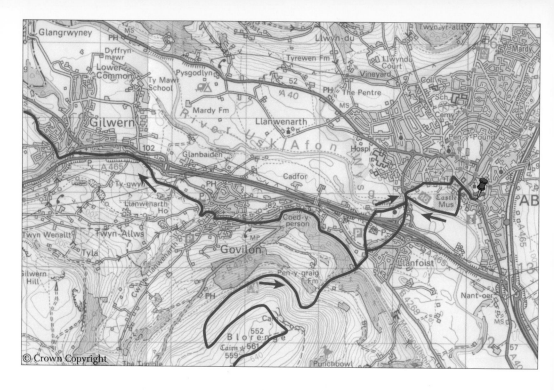

The Brecon & Abergavenny Canal was started in 1796 and in 1812 linked up with the Monmouthshire Canal at Pontymoile Basin, visited earlier in our journey. We'll return here to enjoy an extended canal walk in the next chapter, but for now we leave the canal and continue downhill. The lane passes St Faith's churchyard, where there may be found an obelisk marking the grave of Crawshay Bailey (1789–1872), one of the great ironmasters, who retired to live in Llanfoist House.

Carrying straight on over the road, the route passes a car park and a large plaque marking the Llanvihangel Tramroad of 1814 that once linked the canal with Hereford. This tramroad was opened to Llanvihangel Crucorney in 1814 and reached Hereford in 1819 – it was constructed principally to improve the coal supply to Hereford.

After passing the entrance to the village hall and a garden centre, a subway takes the route under the A465 Heads of the Valleys road, before turning right at a T-junction to pass alongside Llanfoist Cemetery. This is the final resting place of Alexander Cordell, who portrayed much of the industrial history, people and landscape of today's route. Cordell lived near here for many years and now rests in this appropriate setting under the protection of the Blorenge Mountain in his own 'Fair Country'. On reaching the main road, the route turns left across the bridge over the River Usk towards Abergavenny town centre. Turning right at the roundabout, to follow Merthyr Road, we're near the birthplace of John Williams VC, defender of Rorke's Drift (born John Fielding at Merthyr Road on 24 May 1857).

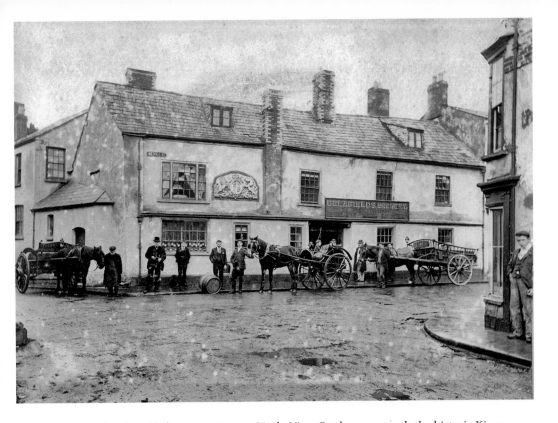

Turning right along Tudor Street to pass Linda Vista Gardens, we reach the historic Kings Arms public house on the corner of Nevill Street. The photograph (*above*) shows the Kings Arms and Delafield Brewery in around 1903. Thomas Delafield was publican for fifty years from 1864 until 1914. He ran his brewery at the rear of the premises and his family owned and ran other pubs in Abergavenny. The frontage of the pub has changed little over time and bears the arms of King Charles II (reigned 1660–85). The old brewery drays have gone, but a nearby micro-brewery has recently served the premises. The Tudor Brewery was perhaps inspired by the Tudor Gate, the town's ancient west entrance, which once stood near here. Ales named after Abergavenny's three iconic mountains – Blorenge, Sugar Loaf and Skirrid – have been brewed. The building probably dates from around 1600. Soldiers returning from the Napoleonic Wars were billeted around the town when there were no barracks available, including at the Kings Arms. They inscribed above the fireplace, apparently with a hot bayonet, 'good quartering forever 1817, King & 15th Huzzars, Hall Troop 24'.

Abergavenny is an important market town with a Norman castle and eleventh-century priory church. There are also numerous historic 'blue plaque' buildings; some of these may be seen walking along Nevill Street, where the Trading Post coffee house was once the Cow Inn. Its partner, the Bull Inn, was near the present post office, giving a clue that this area was probably an early livestock market. There's also a plaque marking premises where white periwigs were made.

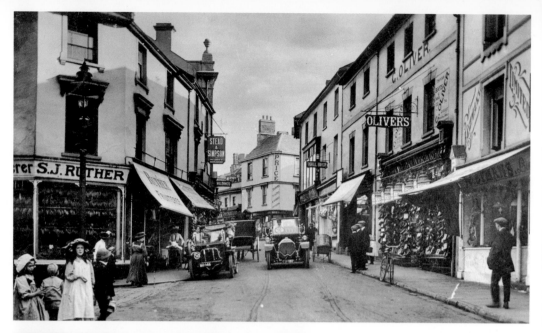

At the end of Nevill Street we meet the top of Frogmore Street. The photograph (*above*) shows Upper Frogmore Street in around 1913, looking back towards Nevill Street and High Street (now pedestrianised). Turning right along High Street, we reach the town hall and market hall built in 1870 to replace an earlier market building. The clock on its tower was donated by the ironmaster Crawshay Bailey.

Markets have been held in Abergavenny since medieval times, and the livestock market along Lion Street takes place every Tuesday together with the popular indoor market (*left*) in the market hall. The indoor market also opens on Fridays and Saturdays. The hall is also the venue for many events, including craft fairs, antique fairs and flea markets. Abergavenny's famous food festival is held every September. The town hall building also incorporates the Borough Theatre, where the Beatles performed in 1963 during their rise to stardom.

Abergavenny to Talybont-on-Usk
18.0 miles (28.9 km)

A day on the 'Mon and Brec'

After exploring Abergavenny, we return to Llanfoist for a long walk along the canal through some of the most attractive scenery of the National Park. The walk can easily be split into two, with Crickhowell as the halfway point. The map on page 74 shows the early part of the walk.

Firstly, along Monk Street we visit St Mary's church, founded as a priory in 1087 by Hamelin de Ballon, the first Lord of Abergavenny. The priory survived Owain Glyndwr's attempts to burn it down in 1404 and, thanks to its Tudor connections, also survived the dissolution of the monasteries, continuing as a parish church. The nave was rebuilt in the late Victorian period, but there are many earlier features of interest. Particularly fine are the stone figures and tombs in the Herbert chapel. But the church's great treasure is its magnificent Jesse Tree, carved from one solid piece of oak. The piece is the base of an altarpiece once 20–30 feet tall and originally highly coloured.

Next to the church is the tithe barn, dating from the twelfth century and lovingly restored as a heritage centre and food hall. On the upper floor there's an Interpretation Centre and a wonderful 24-foot-wide tapestry depicting the story of Abergavenny on a grand scale (*detail below*). Created to celebrate the millennium, the tapestry took over fifty stitchers six years to make and was completed in 2006. Displays in the Centre tell the fascinating story of the tapestry and the town's history.

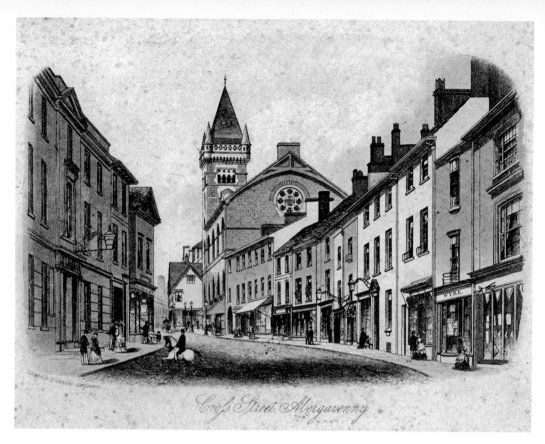

Cross Street Abergavenny

Abergavenny's Tourist Information Centre is near the bus station. Walking from here up Cross Street, there's a fine view of the market hall with the Angel Hotel on the left. The engraving (*above*) by Henry Seargeant was published between 1871 and 1877, when his printing business was at 13 Cross Street. The Angel Hotel is a former Georgian coaching inn on the London to Fishguard road and has welcomed many famous guests. In 1838 a fancy-dress ball was attended by 200 notables, including Sir Benjamin Hall (of 'Big Ben' fame) and his wife, Lady Llanover, as well as Crawshay Bailey. Film stars Gregory Peck, Richard Burton and Elizabeth Taylor have also visited here.

Our route turns left at the Angel, along Castle Street and left again to the grounds of Abergavenny's Norman castle. The picture (*left*) shows brooding clouds over the Blorenge and the castle ruins, perhaps reflecting the dark deeds that took place here on Christmas Day in 1175.

On that day, the Norman lord, William de Braose, treacherously lured local Welsh chieftains to a Christmas celebration at the castle's great hall, where they were brutally murdered. Later, during the Civil War, the castle was a Royalist stronghold before it was destroyed by Charles II to prevent it falling into Parliamentarian hands. On the site of the castle's keep is a nineteenth-century former hunting lodge that now houses Abergavenny's fascinating museum.

Passing to the right of the castle entrance and down the bank, the track turns right across Castle Meadows to the River Usk. This is a pleasant return route to Llanfoist that turns right to follow the riverbank up to the bridge. After we cross Llanfoist Bridge and carry on to the roundabout, the return route forks right, crossing the road to a subway path under the A465 and up to Llanfoist village. The old Llanfoist Inn is ahead (now an Indian restaurant) and turning right here, then left up Church Lane, leads us to the canal, where we join the towpath.

Half an hour's walking from Llanfoist brings us to Govilon Wharf, once a busy canal terminus where the Llanvihangel Tramroad to Hereford and Bailey's Tramroad from Nantyglo met the canal. Govilon also had its own mills and forges, and the wharf was vibrant with activity. Today's scene is much quieter with more leisurely pursuits being followed (*above*).

As we approach Govilon village, a little wooden bridge across the canal leads to Llanwenarth Baptist church (*left*). Founded in 1652, it's the oldest surviving Baptist fellowship in Wales and the present church was built in 1695. At one time, many baptisms were carried out in the nearby River Usk.

The canal continues around a loop and passes under the A465 road before reaching Gilwern. The canal is very popular for leisure activities – navigation was restored in 1970 and the canal is now navigable between Brecon and Cwmbran. It was also popular for pleasure trips a century ago, as evidenced by the photograph (*below*) of a Brynmawr Sunday School outing to Gilwern around 1900. At Gilwern Wharf, the canal crosses Dadford's high embankment that was constructed in 1797 to cross over the Clydach Gorge. Gilwern is historically associated with iron-making in the gorge, and an old tramroad tunnel under the canal leads to the interesting Clydach Valley, where the Llanelly Forge and Clydach Ironworks were once located.

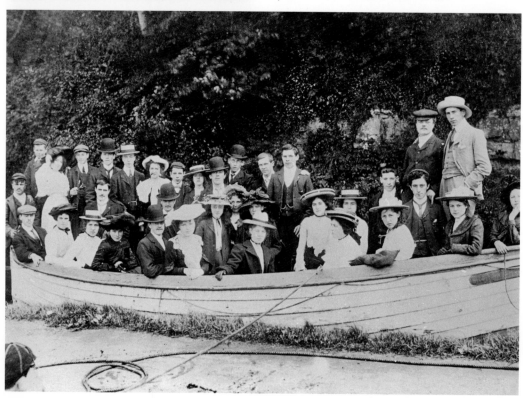

About a mile up the gorge is Clydach House, the birthplace in 1815 of Sir Bartle Frere (*right*) whose family were involved with the ironworks and canal. Frere was a prominent British Imperial administrator, who was responsible for provoking the Zulu War in 1879 when, as High Commissioner in Southern Africa, he sent the Zulu King Cetshwayo an impossible ultimatum. Following this, he ordered Lord Chelmsford to invade Zululand and within days came the disastrous defeat by the Zulus at Isandlwana. The desperate defence of Rorke's Drift mission station took place in the aftermath. In Parliament, Frere was censured for his actions and later recalled to London. He had many distinguished achievements, however, and was an ardent anti-slavery campaigner who ended slave-trading in Zanzibar. He was buried in St Paul's Cathedral in 1884 and his statue stands on the Thames Embankment.

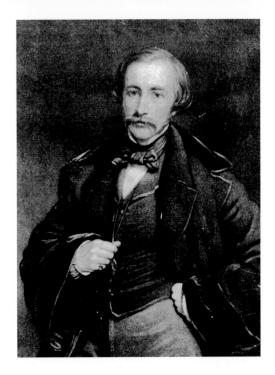

© Crown Copyright

Canal Bridge. Crickhowell

The canal enjoyed its heyday in the 1820s when coal, iron ore and limestone were carried from mines and quarries to wharves, forges and canalside kilns, with products transported on to Newport, Brecon and beyond. With its evocative stone bridges, the canal retains a timeless quality (*above*). On reaching Llangattock Wharf, the restored limekilns are a further reminder of times past. The limekilns were built by the Brecon Boat Company in 1815, and quarried limestone was brought here from the Mynydd Llangattock escarpment by tramroad and inclined plane. The limestone was burnt with coal in the kilns to produce lime, which was removed from the draw arches and transported to market by narrowboat. The picture (*below*) shows the restored limekilns with the colourful cruisers that have nowadays replaced the horse-drawn barges. The dramatic quarries high above the wharf have now been reclaimed by nature and the escarpment includes the Craig y Cilau Nature Reserve. The quarrying exposed one of the most extensive cave systems in the British Isles, with over 12 miles of passages.

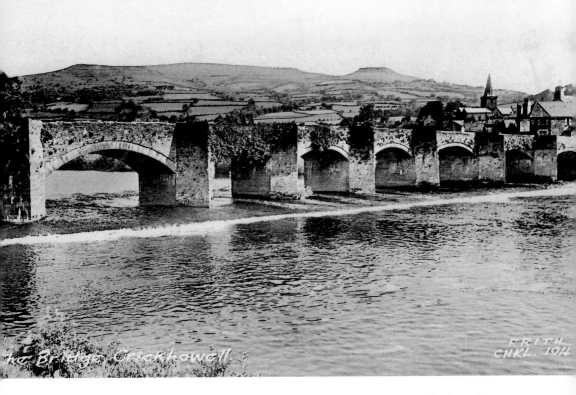

the Bridge Crickhowell FRITH CHKL. 104

After viewing the limekilns we leave the canal at Bridge 115 to follow the lane down through the attractive village of Llangattock to visit Crickhowell. There's a lovely aspect as you walk down the lane towards the river bridge, with the town nestling beneath Table Mountain as Pen Cerrig-calch and the Black Mountains stretch behind.

The scene (*above*) shows Crickhowell Bridge about a century ago, with Table Mountain and the spire of St Edmund's church to the right. The stone bridge was built in 1706, replacing an earlier wooden one, and was widened and rebuilt in 1808 after being destroyed by a flood. Unusually, it has thirteen arches on the eastern side and twelve arches on the west. Table Mountain or Crug Hywel (Hywel's Mound) is an Iron Age hill fort which gives the town its name.

Crickhowell is a thriving country town with much history and is an ideal centre for outdoor activities. After crossing over the bridge and passing to the right of the Bridge End Inn, we continue steeply up Bridge Street towards Castle Road. The ruined thirteenth-century stone castle was attacked and largely destroyed by Owain Glyndwr's forces in 1403, the remains further reduced by much of the stone being reused locally. After turning up the High Street we find ourselves in the centre of town, where Crickhowell's excellent Resource and Information Centre in Beaufort Street is well worth a visit.

One of Crickhowell's most famous sons is Sir George Everest, who was born in nearby Gwernvale Manor in 1790. He became Surveyor General in India, and his meticulous geographical work led to Mount Everest in the Himalayas being declared the highest mountain in the world. The great peak was named after him, the Table Mountain of his home hardly bearing comparison!

83

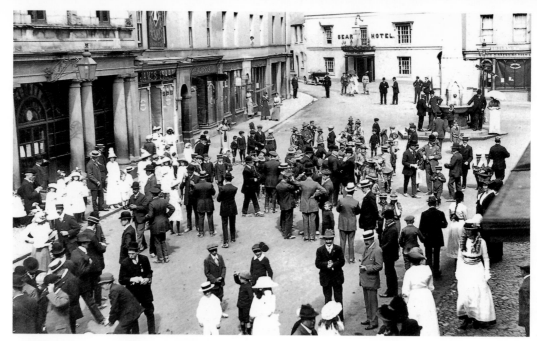

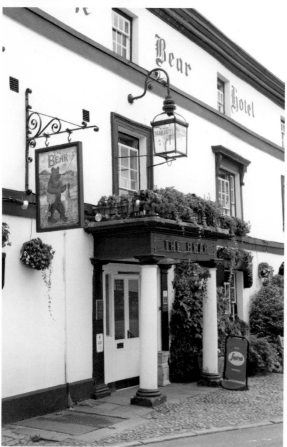

The busy High Street is shown (*above*) in 1908, and the Bear Hotel ahead remains the perfect place to rest and refresh. The old coaching inn, with its cobbled forecourt and welcoming portico (*left*), is said to date back to 1432. The hotel is the social heart of the town and has seen many colourful characters. One of the late owners, the legendary Mrs Dennis, used to assist the local fire brigade by donning a fireman's helmet and stopping the traffic whenever the siren sounded!

Crickhowell is a tempting place to break the walk, but we must press on. After returning over the River Usk bridge, we find a footpath ahead that leads across a field and through the churchyard of St Catwg's church. Llangattock's church was founded in the sixth century, and the present building dates from the twelfth century. Following the lane from here towards Ffawyddog, then angling along a field footpath, we rejoin the canal at Bridge 117.

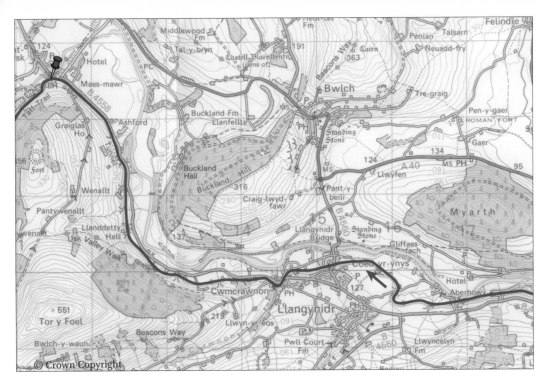

© Crown Copyright

As we carry on along the canal towards Talybont, there's a chance to wave to the crews of the gaily coloured cruisers puttering past at little more than walking pace. They're enjoying a lock-free run along the section between Pontymoile and Llangynidr, which contours around the hill for 23 miles. Walking through this pastoral scene with the Black Mountains stretching out on the horizon, you find the miles slowly melt away.

At Lower Llangynidr, there's an ancient bridge over the River Usk near Bridge 131 – well worth a short detour. The first lock of the day is near the Coach and Horses, a last refreshment opportunity before the final three miles or so to Talybont. There soon follow four other locks as the canal rises up towards Brecon. The scene (*below*) shows Lock 65.

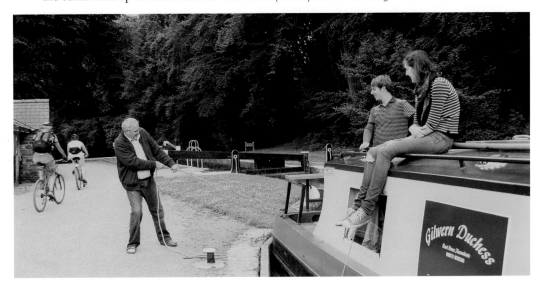

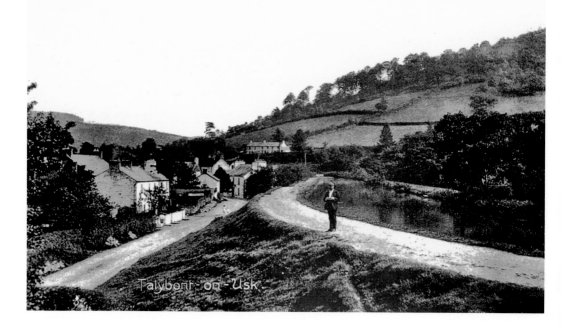

Talybont-on-Usk

After passing Llanddetty Hall, we arrive at the south portal of the Ashford Tunnel, which is 375 yards long and has no towpath. The barges used to be worked through the tunnel manually while the horses were taken over the top, which is where the route now runs. Passing the Travellers Rest, we reach Talybont Wharf, where an impressive row of limekilns survives on the other side of the canal. There's an old tram on display here with an informative signboard illustrating the scene at the wharf when limestone was once brought along the Brinore Tramroad to be discharged into the kilns.

The Brecon & Abergavenny Canal was amalgamated with the Monmouthshire Canal in 1865 to become the Monmouthshire & Brecon Canal, but its business gradually declined as the railways developed. The canal passes under an old metal railway bridge where the Brecon & Merthyr Railway once crossed over. Immediately afterwards, the canal reaches Bridge 143 and an aqueduct over the Afon Caerfanell. The White Hart and Star Inn welcome us as we enter the village of Talybont-on-Usk, ending our long day's walk along the 'Mon & Brec'.

The old picture (*above*) shows the village with the canal flowing gently behind the Star Inn. A breach of the canal here in December 1994 caused serious flooding and the Star Inn was badly affected. The Star once had tea rooms next door but is now well known for the quality of its real ales, having won several CAMRA awards.

Talybont-on-Usk to Brecon

15.2 miles (24.5 km)

The Brecon Beacons

The final chapter features a strenuous walk over the Brecon Beacons that should only be undertaken by experienced and properly equipped mountain walkers. It's recommended as a summer route, in good clear weather with long daylight hours to tackle the 15-mile route and around 3,300 feet of height gain. An easier alternative is to continue along the canal for a leisurely 7 miles to Brecon. Another option is to shorten the route by breaking off to Storey Arms, from where a bus may be taken to Brecon.

The walk starts on an old tramroad then crosses the Caerfanell stream to Aber village before heading steeply uphill onto the ridge of the Brecon Beacons. The high ridge leads on to Penyfan, the highest mountain in South Wales at 2,906 feet, before the route descends into the valley of Cwm Llwch to follow the lanes into Brecon.

We start from Canal Bridge 143, behind the White Hart, and follow the Brinore Tramroad for a short distance. The 12-mile tramroad was opened in 1815 to bring coal from the collieries near Rhymney and limestone from Trefil quarries down to the canal at Talybont Wharf. Tolls were charged for use of the track and the trams were horse-drawn with the hauliers using gravity power on the downhill sections, 'spragging' the wheels with a piece of wood as a rough form of braking. The arrival of the railway in 1863 led to the tramroad's decline and closure, but it now forms an attractive bridle path.

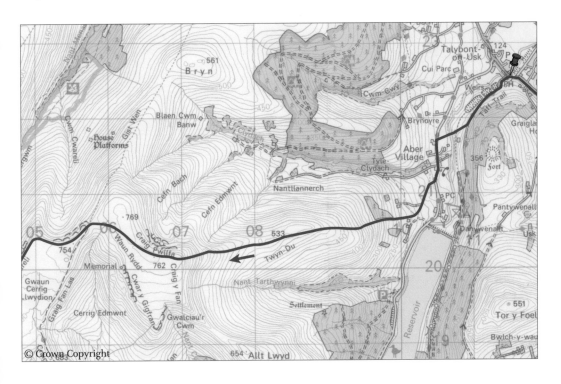

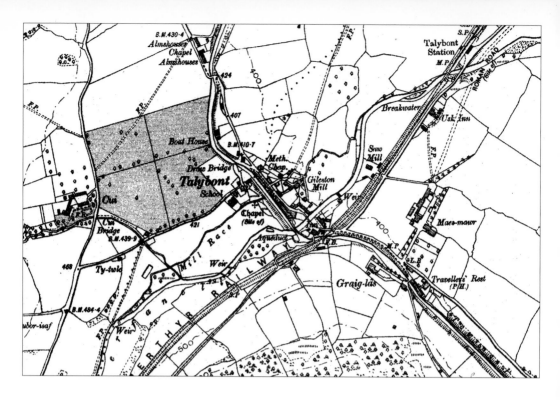

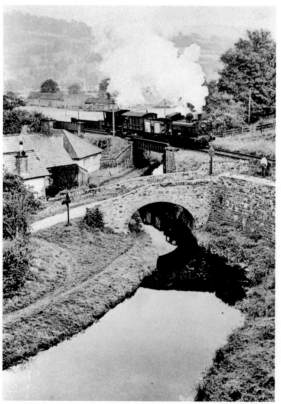

The 1905 6-inch/mile map of Talybont (*above*) shows the Brecon & Merthyr Railway crossing the canal in addition to the tramroad it superseded. The nickname of 'Breakneck & Murder Railway' was well earned due to the numerous accidents on its steep gradients. The steep section from Torpantau down into Talybont was known as the Seven Mile Bank, and in the tragic 'Wild Run' of 1878 a spectacular crash occurred when a train of thirty-seven wagons and three locomotives accelerated out of control down the bank. By the time it crossed the canal bridge, it was speeding at about 60 mph and, when it reached the curve just after Talybont station, it left the rails and plunged to destruction. Four of the six enginemen lost their lives.

The picture (*left*) shows a Pannier tank locomotive on the canal bridge before the railway met its own demise in the Beeching cuts of the 1960s.

The tramroad initially shares a part of the Taff Trail and passes a small herb garden dedicated to Henry Vaughan (1621–1695), the metaphysical poet and doctor from nearby Llansantffraed. His spirituality and the beautiful surrounding countryside had an inspiring effect on his poetry, as the following lines from his poem 'The World' portray:

> I saw eternity the other night
> Like a great ring of pure and endless light,
> All calm as it was bright,
> And round beneath it time in hours, days, years,
> Driven by the spheres,
> Like a vast shadow moved in which the world
> And all her train were hurled.

After about half a mile, we leave the tramroad, turning right through a kissing gate to follow a short section of the Usk Valley Walk down under an old railway bridge and then across a footbridge over the Afon Caerfanell. Turning left then right, the route leads up to Aber Farm, where we turn left along the lane. After about 600 yards the route turns right up a track signposted 'To the Hill – I'r Bryn'.

Following further signs 'To the Open Hill' and climbing upwards, the path eventually emerges through a gate onto the open hill. The route continues up through the bracken in a general westerly direction to Twyn Du, then steeply up to the beehive-shaped cairn at Carn Pica. On the way up there are great views of Talybont Reservoir looking back. The reservoir, with its impressive 1,400-foot-long dam, was built in the 1930s to supply water to Newport, flooding the valley of the Caerfanell.

The route continues over Waun Rydd, with the twin summits of Penyfan and Corn Du appearing as landmarks ahead.

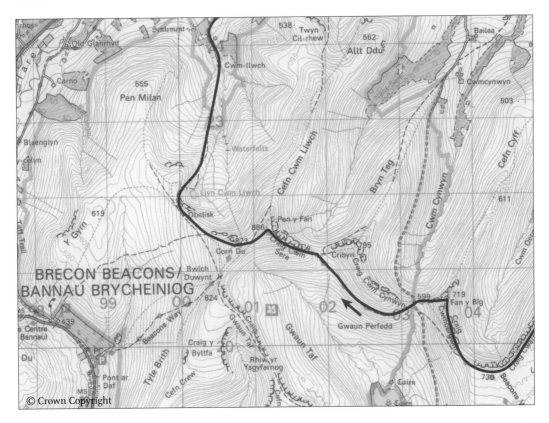

© Crown Copyright

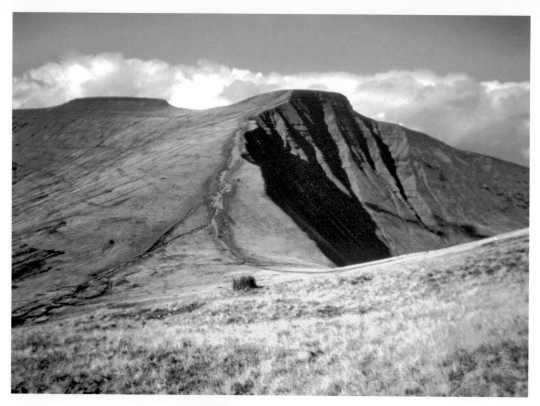

After crossing some boggy ground, the ridge is reached where the route turns left to follow the ridge path around towards Penyfan. There's a fantastic sweeping view down into the valley from here, but there's a precipitous drop so it's important to keep to the path, well away from the edge. There are fantastic views of the Beacons as the path runs around the horseshoe to the peaks of Fan y Big and Cribyn. Our route bypasses Cribyn to reduce the amount of climbing, but this may be included by the really energetic!

The photograph (*above*) shows Penyfan from Cribyn with Corn Du behind. The severe footpath erosion has been addressed by the National Trust in recent times. Careful repair with steep stone steps is helping to protect the routes from damage inflicted by countless walking boots. The final ascent leads to the highest summit in southern Britain – the picture (*left*) of early climbers on Penyfan shows there are more exacting routes to the top. After continuing on to Corn Du, the route drops steeply downward on the path leading towards Storey Arms before forking right to the Tommy Jones obelisk.

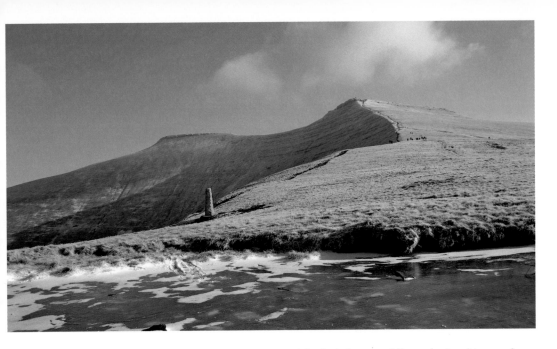

The inscription on the obelisk relates the tragic story of the little boy, aged five, who lost his way down in the valley at Cwm Llwch in 1900 and whose body was found at this high spot twenty-nine days later. The photograph (*above*) shows the obelisk in wintertime, when the Beacons can be a much more challenging environment. From the obelisk, the path continues around and down past the lake at Llyn Cwm Llwch and into the valley.

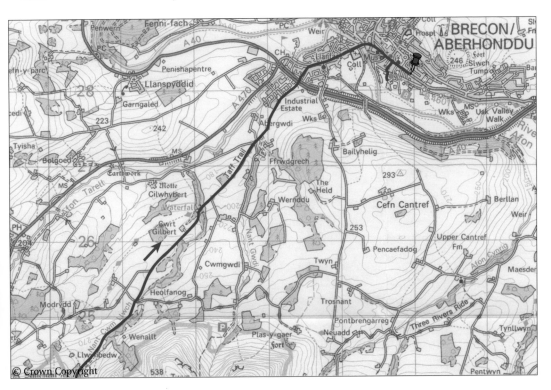

© Crown Copyright

The track descends past Cwm Llwch Farm, bypassing the farmhouse over a couple of stiles, before continuing alongside the Llwch brook bubbling down to the right. The route follows the lane straight on to Pont-rhyd-goch, where there are attractive waterfalls, and rejoins the Taff Trail, continuing along Ffrwdgrech Road. The industrial estate to the left is the home of the Breconshire Brewery – their ales, including 'Cribyn' and 'Rambler's Ruin', are better sampled at the end of the walk!

The main road is joined at Llanfaes, near the Drover's Arms, reminding us of the old drovers' route that once passed this way. A busy horse fair used to be held along Bridge Street in Llanfaes, which is now our route leading towards the River Usk bridge. Christ College to the right was founded by Henry VIII by Royal Charter in 1541 after the dissolution of the former Dominican friary that existed there for 300 years. The modern public school was founded in 1855 by Act of Parliament. The famous school is known, among many other things, for its rugby rivalry with Llandovery College.

There's a splendid view across the river of Brecon Castle and the Castle Hotel. A walk up to visit the hotel is rewarded with a magnificent vista of the Brecon Beacons, as well as welcome refreshment. The photograph (*below*), taken from the castle in around 1900, shows the bridge with the peaks of Cribyn, Penyfan and Corn Du in the distance. Christ College is hiding behind the trees.

The Castle of Brecon Hotel was established in 1809, adjoining the remains of the Norman castle, and became one of the first hotels in Wales. The town of Brecon (Aberhonddu) grew up at the confluence of the Honddu and Usk rivers; the hotel sits on a bluff between them. The picture (*above*) shows a fine line-up of motor cars on the hotel forecourt in the 1960s.

Nearby is the ancient cathedral, a place of worship since Celtic times. The Normans established here in 1093 a Benedictine priory that later became a fortified church, described as 'half church of God, half castle against the Welsh'. Giraldus Cambrensis, the great traveller through Wales, was archdeacon of Brecon in the twelfth century – our paths previously crossed with Giraldus at Llandaff.

From the river bridge, the way into Brecon town centre leads along Ship Street, now much changed from the scene around 1900 (*right*), looking up towards High Street.

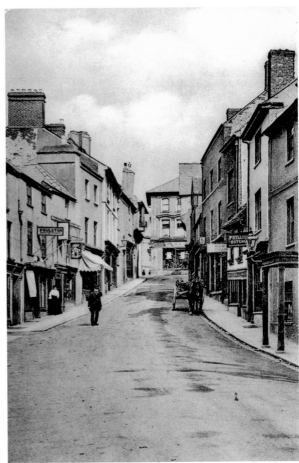

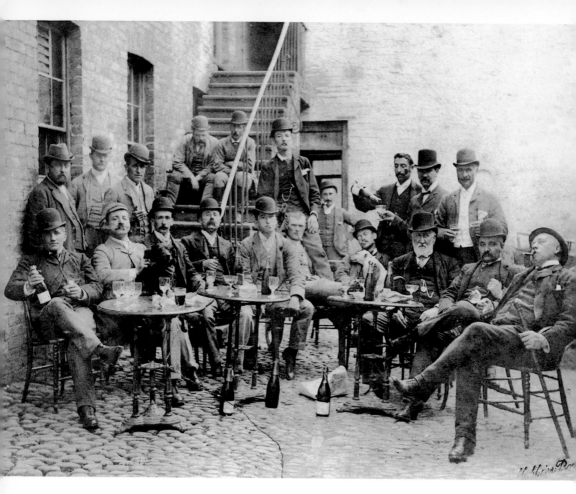

We've finally arrived at our destination, having journeyed from the southernmost point on the island of Flat Holm to the historic mid-Wales town of Brecon. Along the High Street, on the right, is the Sarah Siddons Inn, birthplace in 1755 of the leading actress of the eighteenth century who wowed Drury Lane with her performances of Lady Macbeth. Continuing past St Mary's church and the statue of Wellington, the Georgian façade of the Wellington Hotel appears to the right. The photograph (*above*) was taken in the yard outside the Wellington Hotel on the day after the visit of the Duke of Clarence to Brecon on 17 September 1890. Noticeably, these august gentlemen are enjoying bottles of champagne rather than pints of ale!

Further on, the Brecknock Museum and Art Gallery is housed in the handsome Shire Hall, once the town's courthouse, and the excellent exhibits here include a realistic court scene.

Although Brecon is a traditional market town, it's also a military centre with a long and proud history. Along The Watton, the Regimental Museum of the Royal Welsh is housed in a building that was an armoury for the Breconshire Militia during the Napoleonic Wars, when French prisoners were incarcerated in the town. Soldiers from Brecon were sent to quell the Chartist riots in Newport in 1839, and the 24th Regiment of Foot (later the South Wales Borderers) was despatched to the Zulu War from here.

The Regimental Museum is a must and Alphonse de Neuville's painting (*above*) depicts the epic defence of Rorke's Drift in 1879. The Zulu War has featured several times in our journey, and the story, immortalised in Stanley Baker's film *Zulu*, still resonates today. Pride of place must go to John Williams VC (1857–1932) (*right*), who was born as John Fielding in Abergavenny and who lived most of his life in Cwmbran. His Victoria Cross citation describes his actions in the hospital at Rorke's Drift when, after he held out until running out of ammunition, the Zulus burst in and assegaied a number of his companions. He succeeded in knocking a hole into the next room and, taking two patients with him, found Private Henry Hook. Together they fought off the Zulus with their bayonets while breaking through three more partitions, enabling them to bring eight surviving patients out into the inner line of defence. A hero of Wales indeed!

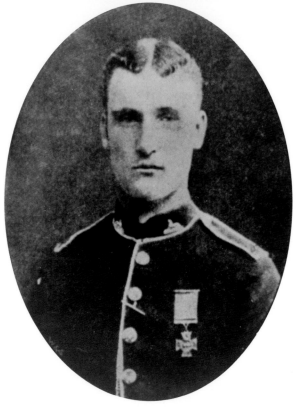

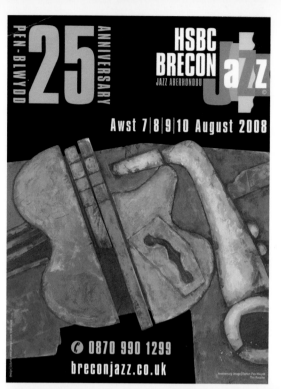

Returning along The Watton, a left turn on Rich Way leads to the attractive canal basin and Theatr Brycheiniog, Brecon's vibrant performing arts centre, opened in 1997. The theatre has hosted many famous artistes and has been one of the major venues for the world-renowned Brecon Jazz Festival, which celebrated its 25th anniversary in 2008 (*left*). The hugely popular festival with its unique carnival atmosphere takes place every August, presenting top national and international performers as well as showcasing alternative and experimental genres of music.

The canal reached its terminus at Brecon in 1800 and soon the Brecon Boat Company was trading from its wharves, operating a fleet of twenty canal boats – each able to carry over 20 tons of coal or limestone. Pleasure boats have now replaced the working vessels and the tranquil scene (*below*) is very different from the clangour and bustle of two centuries ago. A pleasant spot indeed to end our Walk Through Time.